The Seven Key Elements of Fiction

L.P. Wilbur is the author of twenty-six published books, including four bestsellers. A professional writer for over twenty-five years, he has seen more than 5,000 of his articles published, and has received five national awards for writing. He lives in Jacksonville, Florida.

By the same author

How to Write Songs That Sell
Money in Your Mailbox
How to Write Articles That Sell
Stand Up – Speak Up – or Shut Up:
A Practical Guide to Public Speaking
How to Write Books That Sell
A Handbook for Making Dreams Come True
The Fast Track to Success
On Your Way to the Top in Selling
Getting Up When You're Down
How to Make Money in Mail Order
How to Enjoy Yourself:
The Antidote Book to Unhappiness and Depression
Living Your Faith
Handbook of Magazine Article Writing (Special Section)
Holding Audience Attention

The Seven Key Elements of Fiction

L.P. WILBUR

ROBERT HALE · LONDON

© L.P. Wilbur 2001
First published in Great Britain 2001

ISBN 0 7090 6530 2 (Hardback)
ISBN 0 7090 6970 7 (Paperback)

Robert Hale Limited
Clerkenwell House
Clerkenwell Green
London EC1R 0HT

The right of L.P. Wilbur to be identified as
author of this work has been asserted by him
in accordance with the Copyright, Designs and
Patents Act 1988

A catalogue record for this book is available from the British Library

2 4 6 8 10 9 7 5 3 1

Typeset by
Derek Doyle & Associates, Liverpool.
Printed in Great Britain by
St Edmundsbury Press Limited, Bury St Edmunds
and bound by
Woolnough Bookbinding Limited, Irthlingborough

This book is dedicated to John Hunt, a good friend and talented fiction writer, with thanks for the discussions we have shared about fiction and its great potential.

I also dedicate the book to all writers of fiction and readers everywhere who enjoy reading works of the imagination.

I salute all those new fiction writers of the twenty-first century as it unfolds. May they find their wings via the written word and bring their fictional dreams to life.

Contents

Part I: Plot
1. Beginnings — 11
2. The Three Basic Plots — 18
3. The Fictional Dream — 22
4. Experience — 36
5. More Happens Than Meets the Eye — 43
6. Outlines and Plot Points — 54

Part II: Conflict
7. Man vs. Man — 65
8. Man vs. Himself — 74
9. Man vs. Nature — 80

Part III: Setting
10. Establishing Your Setting — 89
11. Setting in Different Times — 92
12. Atmosphere and Setting — 98
13. Know the Period You Are Writing About — 105

Part IV: Dialogue
14. Realistic Dialogue — 112
15. Listen to Your Characters — 116
16. The Key to Good Dialogue Is the Response — 120
17. The Speech Habits of Ordinary People — 126
18. Silence — 132

Part V: Point of View
19. Who Is Telling the Story? — 139

| 20 | First Person Narrative | 142 |
| 21 | Third Person Narrative | 149 |

Part VI: Style
22	A Brief History of Style	157
23	Techniques of Style	163
24	Diction	168

Part VII: Character
25	Every Story Is a Story About Characters	175
26	Twenty-five Ways to Create a Character	180
27	The Series Character	183
28	Flat Versus Well-Rounded Characters	186
29	Make Your Characters Unforgettable	190

PART I
PLOT

1 Beginnings

'Indeed, sister,' said Dinarzade, 'this is a wonderful story.'

'The rest is still more wonderful,' replied Scheherazade, 'and you would say so if the sultan would allow me to live another day, and would give me leave to tell it to you the next night.'

Schahariar, who had been listening to Scheherazade with pleasure, said to himself 'I will wait till tomorrow; I can always have her killed when I have heard the end of her story.'

The Arabian Nights

Beginnings are a doorway into an author's world: if successful, the readers enter with ease; if obscure, they may feel shut out, and turn away, closing the door behind them.

In *The Arabian Nights*, capturing her audience's attention is a matter of life and death for Scheherazade. Married to a sultan who infamously beheads his wives after their wedding night, Scheherazade uses all her storytelling wiles to sustain her husband's interest. Each night, she stops halfway through her tale until the next, when she finishes that particular tale, and moves on to tell another, and so on. So enthralling are her wonderful stories that each morning, the sultan overcomes his murderous urges in order to find out what happens. The plot for this listener provides the backbone of the story, its twists and turns keeping him in suspense.

In many ways, we might compare Scheherazade's fictional dilemma to that of a professional author: if you do not master the art of grabbing your audience's attention immediately, your

book will not survive. Notice how many of today's films (clearly intended for the attention-deficit generation) open with a 'double whammy' hook. James Bond films, famous for their predictable structure, always begin with a completely original action scene to get the viewers involved and rooting for their hero.

An effective beginning should set up expectations which the reader will find either confirmed or modified by the text he goes on to read. Familiarity has its very distinctive uses in fiction, and certain beginnings bring with them familiar values; if I were to begin a novel with 'Once upon a time', then you might fairly assume that I was either writing a fairy tale:

Once upon a time, there was a little girl who wore a red cape . . .

or by using that construction I was creating a form of parody:

Once upon a time my brother barbecued the dog.

Fairy tales used this particular construct to create a passage into the mythological world. Most of the fairy tales we know so well today were passed on through an oral tradition by West European, Icelandic and Slavic mythology; for a speaker could easily grab his listeners attention by a simple, clear opening, without much explanation of the history of the characters and lands around which the story revolves. So, *Once upon a time there was a little girl who wore a red cape* will confirm our expectations that the beginning will lead on to a fairy tale. The reader is in some way interacting with the author's fictional world (remembering other stories that have started that way, wondering how or if this one will use it differently and so on), and this occurs even before the text gets underway. So, as long as the reader is willing to involve himself in reading (interpreting) the story, and you give him enough proverbial rope, he'll stay with you throughout.

But how to think up new ways of enticing the reader into

your world, without slipping accidentally into parody or clichés? A good way of understanding beginnings is to look at how other authors start their books with their very first line. Many eighteenth and nineteenth-century novelists who were responsible for some of the more weightier classic tomes, opened their novels with definitive assertion. The first lines of Jane Austen's *Pride and Prejudice* have become one of the most famous statements beginning a novel.

> It is a truth universally acknowledged, that a single man in possession of a good fortune, must be in want of a wife.

Do all landed men pine for wives? Does everyone think this? Whatever the truth, such a sentence succinctly introduces the theme of the book – marriage. A statement like this necessarily invites a good deal of questioning, which quickly integrates the reader in the world of the novel.

Leo Tolstoy's *Anna Karenina* opens in a similar way:

> Happy families are all alike; every unhappy family is unhappy in its own way.

Now, what are *your* expectations for the rest of the novel? Is this statement correct? Are the family at the centre of the novel going to be happy? Is Tolstoy implying that happiness in families is rather bland for a novel's subject, and he's not going to waste good ink by writing about it? Again, Tolstoy is engaging the reader by making him question his own opinions and experiences as soon as his book begins. This, in fact, is a fundamental part of *Anna Karenina*'s presentation of adultery. Reading on, we discover (probably with some relief) that this is not going to be a treatise on families and happiness, but it is, in fact, a third person narrative of a normal family's activities.

> Everything was in confusion in the Oblonskys' house. The wife had discovered that the husband was carrying on an intrigue with a French girl, who had been a governess in their

family, and she had announced to her husband that she could not go on living in the same house with him.

As well as turning his reader's eyes inwards, Tolstoy effectively presents a gap in his text – between the presentation of a statement (instruction) to *showing* the situation. In other words, had he continued to discuss the trials of the family in such a one-sided manner, he would be ignoring the future presence of his reader, who may have just shut the book, thinking: *Whatever you say, Leo, now where's that Dostoevsky novel I bought yesterday*. The power of suggestion alone gets his point across without him having to state that Oblonsky's family was deeply unhappy (they are only described as in 'confusion' here).

The first line of Charles Dickens' *A Christmas Carol* also begins with a statement – this time about a specific character:

> Marley was dead: to begin with. There is no doubt whatever about that.

Already, we are asking questions: who is Marley? Why did he die? Who is this Scrooge person who appears in the third sentence? Why is it so important to establish Marley's death? Because he has told us that Marley is dead, we assume that, although Marley is important, the story isn't going to be about him, but that his death is fundamental to the story.

> Scrooge knew he was dead? Of course he did. How could it be otherwise? Scrooge and he were partners for I don't know how many years.

Dickens then proceeds to inform the reader about Scrooge ('a squeezing, wrenching, grasping, scraping, clutching, covetous old sinner!'). He thus satisfies the reader's expectations, which include the author adding to their very limited knowledge of the late Marley's old partner. The very first ghost to visit Scrooge is that of Marley, and when the miser asks his old partner to offer words of comfort, the phantom replies, 'I have none to give. I

cannot rest, I cannot stay, I cannot linger anywhere.' His punishment for years of underhand business and avarice has condemned him to chains; his ghost arrives to save Scrooge from a similar fate.

The author cannot start at the inception of the novel's story; for that, he would have to go back to the beginnings of time. The plot should influence the point at which the reader enters. From that moment on, as soon as he enters the fictional world, he must want to stay there. So, in terms of plot (although this also applies to character development), as soon as the reader enters the fictional world, he should at least start to form his expectations, rather like the initial assumptions of *Once upon a time*.

Returning to *Anna Karenina*, Tolstoy wrote many drafts before he decided on the novel that has become a literary classic today. There were roughly five drafts in all, each with a very different beginning, and all, in some way, relating to Tolstoy's plot and character development. The very first draft opened with guests at a salon (a fashionable gathering, not a hairdresser's) where the rich and beautiful congregate to swap gossip and eye each other's new dresses, and where Anna (here called Tatiana) thrives amongst her friends. At this point, Anna and Vronsky have already met, and their affair is long established. Anna upholds her reputation as a lascivious whore and the novel ends with Anna's suicide.

Draft two began in the same way, and Anna (here Anastasia) is as coarse as in the previous draft, with the added insult that everyone, apart from Vronsky, thinks Anna is rather rough (the proposed title *Great Girl* is sarcastic).

Drafts three and four introduced Levin as a crucial character, and he starts the novel, as he also does in draft five, at a cattle show and Anna and Vronsky meet at the railway station shortly afterwards. Anna at last resembles the contradictory and charismatic woman who has embedded herself into international consciousness.

Just as Tolstoy's respect for his heroine increased as he piled draft upon draft, so his beginnings evolved to fit that idea. The

soirée openings of the first few drafts connected Anna to a superficial world of immorality. As Anna developed into a rounded human being, and Tolstoy introduced more plot strands, he also felt the need to introduce larger themes; from this point onwards he concentrated on Levin, and Anna's brother, Stiva Oblonsky (who opens the final draft). This places Anna in a different sphere, not merely as the shallow socialite, but representing an integral part of a family.

Also, instantly noticeable about the difference between the drafts is at which point the reader enters the story's plot; in the middle of the affair, at the beginning or well beforehand. As the old saying goes, every good story should have a beginning, middle and an end; this might be cliché, but it is also sincerely accurate. Screenplay classes frequently teach a three part structure, creating balance and harmony throughout the story. Classical drama also taught the three part plot system and the philosopher Aristotle became famed for what is now known as the Aristotelian system, which basically suggests that everything should have beginning, middle and end.

But this only relates to textual content – the true beginnings of the plot do not lie in the first sentence; they come much earlier than that. Just as no human can remember the very moment they were born, so the novel, a world unto itself, does not start with its genesis, but at some point later. When creating beginnings, the writer should always be aware of a mini-history to which the reader can refer back. This builds up a fictional timeframe in the text; as there is a future (the furtherance of plot), so there is a past (perhaps the reason why a character is scared of water), which will inform the *now* of the text. This type of interaction, which is important from the very first word of the novel, is called 'metamemory'. *Meta* is a Greek word, meaning something referring back to itself. As he interacts with the text, the reader continually sifts and interprets information, which is stored as a kind of fictive history.

In her very successful and critically acclaimed series of books, J.K. Rowling uses metamemory to draw her reader deeper into her character Harry Potter's world. With this very straightfor-

ward technique, she describes an event or offers a piece of new information, and a hundred or so pages later refers back to it with minimal clues, allowing the reader to work it out by remembering what he was shown. For instance, on page 42 of *Harry Potter and the Prisoner of Azkaban*, Harry is writing an essay in Florean Fortescue's Ice Cream Parlour in the magical Diagon Alley, and is plied with ice creams by Florean, the owner. Nothing is mentioned about this until page 234, when Harry sits the History of Magic exam, remembering everything Florean had told him 'while wishing he could have had one of Fortescue's choco-nut sundaes with him in the stifling classroom.'

Film narrative uses metamemory to establish themes and create new twists. In the *Indiana Jones* trilogy, Indiana reveals that he is scared of snakes. In the third part (*Indiana Jones and the Last Crusade*), during a flashback, we see him as a boy, crawling through a large crate of sizeable cobras. This is metamemory working in reverse, and provides historical information that in turn justifies present actions. Careful use of metamemory can create artificial layers of information that establish a mini-history, and, immersed in an organic world, the reader understands the past, lives in the present of the narrative, and looks forward to the future, just as the power of Scheherazade's narrative kept her murderous husband preoccupied as soon as her tale began. . . .

2 The Three Basic Plots

Fiction unfolds around three basic plots: man against nature, man against man, and man against himself. Numerous stories and novels may be written with one of these plots as the framework.

Take Frederick Forsyth's novel, *Day of the Jackal*, for example. A professional hit man accepts a contract to kill Charles de Gaulle, then president of France. This plot would thus fall into the man against man category. An interesting point about this novel is the fact that the reader knows De Gaulle survives the hit man's attempt on his life. It is how it happens, how close the killer comes to snuffing out De Gaulle, and the hit man's own fate, that keep the reader turning pages.

Call of the Wild by Jack London is a clear example of the basic plot of man against nature. Most of the story takes place in the northern outdoors.

Another variation of the man against nature plot is *The Cobra Event* by Richard Preston. The novel tells about a genetically changed virus which is about to be spread throughout New York City.

The Strange Case of Dr Jekyll and Mr Hyde, by Robert Louis Stevenson, is an example of the man against himself plot. Jekyll, seeking knowledge of how his potion works on a human, takes it himself and turns into Hyde. The good side of him, as Dr Jekyll, is strong in the beginning and regains control over Hyde a number of times.

Later in the story, the reader realizes that Jekyll is growing

weaker and Hyde, the evil side, is gaining strength. After Hyde goes on several excursions (using Jekyll's body), he finally succeeds in taking full control. At that point, Jekyll has lost the battle to Hyde, who goes about his evil ways and commits his vile deeds in freedom.

Stevenson was fascinated by the dual nature of man and used it as the basic theme for the novel. It is interesting to note that the novel reminds many readers of Oscar Wilde's *The Picture of Dorian Gray*. Gray also goes about his evil ways, but the trigger point is his handsome portrait.

Plot is whatever happens in the story, which can be anything in life, and is one of the most stimulating ways to develop fiction. You simply plan what is going to happen. Decide what the key events are to be. You can even graph them if you would like to see the rise and fall of the story line. Then write what happens in between the major events and you have your full plot.

Some writers divide their works into acts. This helps them to view the entire plot and to decide what should happen in each 'act'. Many novels have a brief interlude between two major acts. You may have to try different approaches to see what works best for you.

Many experts on the novel claim there are no completely original plots. Just about everything you can think of has already been done in the past.

Some novels and stories may appear to combine two basic plots. *Gone with the Wind*, for example, really has two plots going on at the same time. One is Scarlett O'Hara against herself; the other is Scarlett against nature (the Civil War going on around her and destroying her way of life). Some novels may appear to have two plots fighting each other for control. In this case, one will usually be stronger than the other. In Ernest Hemingway's *The Sun Also Rises*, Jake Barnes is struggling to go on despite a war injury which has rendered him impotent. The woman who loves him knows about his injury but is unable to stop loving him. The novel also reveals other characters who seem to be lost in their lives, and all of them take much pleasure from seeing bull fights in Spain.

You can see from the above examples that you have wide scope within the bounds of each basic plot. There have, for example, been numerous novels about rivers and the havoc they cause when out of control. Here is a clear use of the man against nature plot. It does not have to be a river, either. Think of other possibilities in the natural world, like volcanoes, climbing mountains, surviving winters in very cold regions, perhaps trying to reach the South or North Pole, animals on the rampage, and more.

'Shooting an Elephant', an essay by George Orwell, reads like a short story. It tells of an incident in lower Burma in which a magistrate is pressured by the crowd standing behind him to shoot an elephant that is temporarily on a rampage. The crowd wants the tusks and meat the elephant will provide, and they are all screaming for the magistrate to shoot. He finally does open fire, and the magnificent elephant, suspended in air momentarily, falls to the ground but takes a full half hour to die in agony. If this had been a short story, it would have been a variation on the man against nature plot, for what chance did the elephant have against the rifle of the magistrate?

The man against man plot has been around since Cain and Abel, a story which has been done in a modern novel with different names for the lead characters. Mark Krigel's *Bless Me, Father* is a novel about a son whose father is in the mob. The son seeks a better life, and that explains the struggle between him and his father. 'The Killers', the classic short story by Hemingway, is another fine example. The lead character has offended the mob, and they are searching for him. He knows that they will find him one day and is reconciled to it.

Remember all the James Bond novels? Each one matched 007 against a varied assortment of maniacs and power-mad individuals bent on destroying parts of the world, cornering its wealth, ruling it, or some other scenario. Enter James Bond, and then you had a classic example of this basic plot in each of the novels.

This one type of plot can yield all manner of short stories and novels. Think of all the wars of the last century alone, and you have man against man over and over. There are seeds every-

where that would fit this plot category. Men and women in a variety of companies competing for promotion, and the political struggle between all kinds of candidates, line up squarely in this camp.

The man against himself plot is a bit more complicated, though it can clearly be seen in a number of fictional works. *The Lost Weekend* by Charles Jackson and J.P. Miller's play *Days of Wine and Roses* would qualify for this category, for they tell the stories of characters caught up in a battle against alcoholism. If you use this basic plot, it's important to get inside the thought processes of the main characters and show the struggle going on there.

Another vivid example of this kind of plot, as we have seen, is *The Picture of Dorian Gray*. Standing before his handsome portrait, Dorian wishes that he could always remain young and handsome, as he is in the portrait, and not grow old and wrinkled with the ravages of time. 'For that,' he vows, 'I would give my soul.' Time passes but Dorian remains young, though his friends continue to grow older. He is an evil person and begins a string of vile deeds including several murders. He causes the death of a young woman who loved him and even kills the artist who did his portrait, after secretly showing the painter how the portrait is beginning to change and reveal each terrible deed.

Writers who like the man against himself type of plot seem to have ample ideas and starting points for such stories and novels. The film, *The Three Faces of Eve* , for example, explored the multiple personalities of one woman and how each fights for control of her. This won an Academy Award for actress Joanne Woodward, who played the lead role on the screen.

3 The Fictional Dream

The late John Gardener, a successful novelist and Professor of Creative Writing at the University of Iowa, said that, 'The fictional dream must be a strong one to sustain the writer through a complete novel.' It is important to remember this.

Clive Cussler, one of the most successful novelists working today, followed his own advice regarding the power of the premise or idea. Back in the 1970s, long before the hit film *Titanic*, Cussler asked, 'What if they raised the Titanic?' His first novel, *Raise the Titanic*, was a great success.

Cussler knows the sea well and that is what he chooses as his subject. He now uses a continuing character, Dirk Pitt, in all of his sea novels, *Atlantis Found. Iceberg, Cyclops, Dragon,* and others.

Why even start if your fictional dream is too weak, confusing, or limited? You could write for the practice the experience, but to compete with the other fiction in the marketplace today such a flimsy work would be too weak. If brief and crystal-clear concepts are crucial in the film business, and they are, then the same is true for novels.

Twenty years after a New England police chief stopped a homicide investigation, his own daughter, who is now a police officer, reopens the case and finds that a key suspect is none other than her brother. This was the basic concept for a novel titled *Darkness Peering* by Alice Blanchard. In another novel, *The Sparrow* by Mary Doria Russell, humanity makes its first contact with extra-terrestrial civilization. This novel sold for $500,000.

You need a very clear idea of the gist of your story, the action or nucleus of what is going to take place. If you are lukewarm about it, then it is doubtful you will stick with it through all the necessary work and planning. Your fictional dream must hit you, the creator, right between the eyes and deliver a one-two punch, even in a two- or three-sentence concept. Otherwise, you may well be wasting your time, unless you just want to write the work for the sheer practice.

I have often wondered how Charles Dickens got the fictional dream for *A Tale of Two Cities*. How did it hit him? Did he think of a character who, because of his love and admiration for a woman, takes the place of her fiancé, who is about to be killed? Or did he instead simply decide that the French Revolution would be an interesting background for a novel and go from there?

Ideas and seeds for a novel or short story may come from anywhere and everywhere. A chance remark, even a comment by a neighbour, relative or friend, can trigger a writer's mind for a new work of fiction. Ideas are everywhere.

Travel can bring fresh ideas because new surroundings and places often hold seeds for works of fiction. Old legends, stories, anecdotes, journals, and letters may also hold the seeds for all manner of fictional works, but it may need the trained and experienced writer's mind to see them.

The Man in the Mirror is a novel about a reporter caught up in industrial espionage. It is clear how David Ignatius got the seed or idea for this novel. A former foreign correspondent and now editor of one of the major Washington papers, he has the background and knowledge to trigger such an idea. One writer, Bart Schneider, went from creating plays to writing a novel. His first work was turned down, but he learned invaluable lessons which led to his second one being accepted. His playwriting experience could only have helped in fiction, since dramatic scenes are important in imaginative writing. Playwriting experience also helps in structuring a novel.

Another seed may be that too many people do not do anything about the events that happen around them. For novel-

ist Gardner McKay, who was at one time a television star, this was a fictional idea worth developing. He was angry about this truth, and the anger led him to write a novel *Toyer*. It is a psychological suspense novel about a serial criminal in Los Angeles. Instead of murdering beautiful young women, he toys with them and causes them to go into unending comas.

How about the ruthless, cut-throat world of television news as the background for a work of fiction? Bill O'Reilly is a twenty-year veteran of that industry and has long felt that 'television news is a brutal, savage place'. He decided to show it the way it is and did a fictional work titled *Those Who Trespass*.

Obviously, the fictional dream can be anything that sticks in your mind, triggers your emotions, perhaps makes you angry, haunts you in some strange or nagging way. *Shut Up and Deal* is a novel about today's world of poker, which proves that even a game that you love to play, and think about a lot, can evolve itself into a work of fiction. Jesse May left college to go around the world as a professional poker player. The evenings he spent, the interesting characters his path crossed and the lessons he learned about poker led him into his own fictional dream. The dream can involve some more complicated connection the writer makes. Anything may suggest something in the writer's mind. This is one of the marvellous facts about writing and especially about fiction. A writer never knows where or when the next fictional dream will grab the attention.

An older man's obsessions for a teenage girl led to Vladimir Nabokov's *Lolita*. An old man trying to catch a great fish sparked Hemingway's *The Old Man and the Sea*. Three young women arriving in New York City bent on getting somewhere resulted in *The Best of Everything* by Rona Jaffe. A woman starting as a maid in a great house in England and rising to become the owner of a popular store and builder of an empire, led to *A Woman of Substance* by Barbara Taylor Bradford. The fictional dream then can be anything, any idea that haunts a writer, that makes connections or associations in the mind, and spins a tale.

Consider, for example, some of the fictional dreams in

romantic novels. Some of the stories are very well done with believable characters, plots and settings. *Love is a Many Splendored Thing* by Han Suyin told of a Chinese doctor's love for an American correspondent, with Hong Kong as the setting.

Valley of the Dolls, by Jacqueline Susann, was an extraordinary success in the late 1960s. The story of three women in different phases of show business, and what led each to a pill-popping lifestyle, costing two of them their lives, also had its share of romance. One wonders now, decades later, just what the fictional dream was for this novel. Jacqueline Susann obviously knew people in the entertainment business, so ideas may well have been triggered in her mind by basic observations. Whatever form her fictional dream took, it was enough to get her embarked on her novel. Rumours said at the time that she patterned some of her lead characters after well-known stars in Hollywood.

One fact you will discover if you do much writing, is that the fictional dream can nag and hold on to you like a bulldog. It can wake you up in the middle of the night demanding that you develop and work on it. It can pop into your mind while driving in traffic, eating in a restaurant, taking a shower, working on something else, at any time.

A while back I was seized by a fictional dream that gave me no peace, no rest, until I began to develop it. This particular fictional dream was a lead character, a college professor of history who becomes completely obsessed with going back in time to kill Hitler. I named this man Burt Gunther and described him on paper so I knew everything about him including his past, friends, relatives, the work he did, and much more.

So what happened? Burt Gunther became too real for me. This character began to whisper in my ear. I saw him teaching his history classes and knew that a great change was coming for him. I was off and running on this fictional dream, and it gave me no rest, hounding me day and night to keep developing it, writing, and rewriting it.

Every writer knows that the material, story line, and actual details of a novel or short story may be changed, or rearranged, in the completion of the manuscript. I was aware of this

constantly, and often made wholesale changes in the direction and evolution of this fictional dream.

When an idea for a novel haunts a writer and won't desist, it stays with you no matter where you go or what you do. My idea about someone going back in time and managing to kill Hitler, almost became an obsession. Part of my mind, the logical side, argued this fictional idea and pestered me with a single question: history shows and reveals that Hitler was not killed, despite the 20 July 1944 attempt. So I reasoned, why bring this fictional idea to life? The answer was simply that many readers would still find interest in a character who goes back to the Third Reich era and attempts to eliminate the German dictator.

For decades I had read of the incredible number of lives either lost or ruined because of Hitler's rise to power. A reasonable estimate is that 50 million humans either lost their lives or had them turned into nightmares because of war, through being wounded, the loss of loved ones, and betrayal. The point here for a fiction writer is that amazing, incredible facts can trigger your mind and get you playing the 'what if' game. It certainly did in my case. I could not shake the idea of a character going back to that time and at least trying to wipe out Hitler.

I was also aware that in Frederick Forsyth's novel, *The Day of the Jackal*, as described in Chapter 2, the reader knows that General de Gaulle is not killed and that the professional killer trying to take his life fails. It is still, for the reader, a fascinating experience to see how close the killer comes to achieving his goal. This fact then influenced me to go ahead and plot and bring my fictional dream to life on the page.

I urge every fiction writer not to let logic ambush your fictional dream. Go over it on paper. Ask yourself over and over why your idea cannot work? Prove why not. Don't let your mind trick you in discarding what might be a worthy fictional idea. Test it, try it, look at it from all sides and angles, and if you feel it can't work, ask why and how it could be changed. Just don't be too quick to reject fictional ideas in an attempt to find a perfect one.

The novel opens with Professor Burt Gunther pacing up and down before his Midwestern University history students. I felt that the time traveller in the story should be a college professor, as this would make him seem more accessible to the reader.

The class is currently on the Second World War era, and Gunther is clearly obsessed that Hitler was allowed to rise to such power. He asks his students if they can say why the Nazi dictator was not stopped.

An earlier film, *Judgment at Nuremberg*, had a major scene in which the defence attorney makes an impressive case for the West sharing blame for Hitler's rise to power and not Germany alone. With these influences in mind, I had Gunther discuss the why of Hitler with his students.

The professor gives his own reasons, the class ends, and the students file out with knowing glances among them. Gunther's tirades on Hitler and the Third Reich are well known on campus, and the students are bored by it by now.

As the novel progresses, I needed to put Gunther into conflict – not just with himself – but some other pressure on him. I decided that he had enemies on the faculty, and some of them were calling for his resignation claiming that he was unbalanced. Fortunately, Gunther also has friends on the Board of Regents of the university, and he also has a good friend in the university president.

When developing fiction, as every writer discovers, the need to invent is continually important and especially in writing the first draft. I felt at this point in the story I needed to show Gunther's obsession in a dramatic way. I came up with a recurring dream he would have on different nights in which he sees Jews being put on trains headed for Nazi death camps. Each time he wakes from these dreams, he curses Hitler and swears that if he had only been there in Berlin, he would have risked his life to kill him.

I had Gunther reflect his views in conversations with faculty friends, saying that the world must never forget what happened.

Then I needed to get him, as the lead character, to Berlin. How to do this stumped me for some time, but I finally came up with the idea that he sees a shocking news story and reacts with action.

> The tabloid headline reads that Hitler is alive and well, now in his nineties, and living out his last years in Argentina. Gunther dashes out of the store.
>
> He talks over the headline with Travis Russell, the head of the department of Journalism at the University, and Russell denounces the story as one of those sensational tabloid fabrications used to sell newspapers. Obsessed as he is, Gunther refuses to believe the story is a hoax, but eventually Russell convinces him.
>
> The university president offers Gunther a one-year sabbatical with pay, thinking that a year off will vitalize the man and get his mind off Hitler and the Nazi era. Gunther accepts the sabbatical. He sets himself up in an apartment in Berlin and begins research on the plots to kill Hitler during 1935 to 1945. His obsession grows worse while he visits the historic landmarks of the city including the Kroll Opera House, the Grünewald, the Dahlem Museum, and places where Hitler spoke to huge crowds.

Many novelists fall in love with the joys and fascination of research. I knew I needed to learn about Berlin at that time and spent many hours going through books and looking at various maps.

When I learned that this novel idea would give me no rest until I brought it to life on the page, my first thought was that I needed to go to Berlin and this would have saved me a lot of time. I believe that if any fiction writer can go to the actual location, the scene, where a planned (or historic) action or series of events takes place, so much the better. On the other hand, *Nicholas and Alexandra*, the novel about the Russian

czar and his family, was written entirely with no travel to Russia.

> To proceed with my story, I had Gunther interview older Germans who lived in the late 1930s and early 1940s, and he walks the streets of West Berlin at night talking to himself. I had his obsession give him no rest. Here was a place of tension, and I wanted to incorporate that sinister atmosphere into my scene, making the sinister atmosphere more believable to the reader.

I believe a true novelist can often sense what is needed in a story in progress. Right or wrong, I wanted to introduce a female character who Gunther would meet and like. This character evolved to being a divorced teacher from Seattle who is touring Europe with two other teachers.

> He takes her out and when this teacher, Teresa Cavendish, is about to leave Gunther asks her to stay there, and help him with his book by typing his notes and acting as his secretary. They are romantically involved by now, and she agrees, hoping that he will propose by the end of the summer and the beginning of a new school term back home.

While writing this novel, I often thought about how Charles Dickens dramatized many of his scenes and I felt that more dramatic scenes were needed. I advise every fiction writer to dramatize as your story unfolds. This objective has been a great help to me.

How to do this in my story was my question. I decided to place Gunther near the Brandenburg Gate and border separating (at that time) East and West Berlin.

> He sees two young men shot while trying to escape over the wall into West Berlin. This incident brings back his hatred for the Nazis and Hitler in a current way. He blames them for

making Berlin a divided city through the rise and fall of the Third Reich.

Sometimes it can be useful if a lead character very briefly seems to vanish, but it must be short. Cutting away like this can be intriguing and can increase interest and suspense.

To advance the story should be the single battle-cry of every fiction writer. My daily objective was to advance the novel in the strongest and most believable way possible. I therefore decided to have Gunther disappear for two days.

Teresa becomes worried and looks everywhere for him. He calls her two nights later at three in the morning. He explains that he has been in Munich interviewing a man who was on the German Army General Staff. The man was near Hitler on a number of occasions.

The interview has escalated Gunther's obsession, and he wonders why those who sometimes came close to Hitler (and were against him) failed to try to kill him. He swears to Teresa he would have gotten the dictator for sure, if given half the chances that came to others. Meanwhile Gunther's book moves forward when he is not busy travelling or investigating the past.

At this point in the story I knew it was time to get him back in time. The question that nagged me a lot was just how to do it. Here I would like to offer what I feel is sound advice for any fiction writer: when you find yourself stumped with a fictional problem, sleep on it. By sleeping on it I mean turning the problem over to your subconscious. This method may not be foolproof, or always work, but many times it will. I have discovered that sleeping on the problem will often hand it to the subconscious to sort out. What happens is you wake up the next morning with the answer clear in your mind. This proved to be the case in this story. I woke up knowing how to get him back to the Nazi era.

One day after dinner with Teresa, Gunther goes back to the library for a few more hours of research. He checks some things and reads for a while from several books on the Third Reich. After some time, Gunther falls asleep. When he wakes up, he feels strange and the library is deserted. He comes out of the main entrance and sees that it is raining. He heads for the parking lot and his car, but something has happened. Neither his car nor the parking lot is there. Baffled, he walks down the street in the pouring rain.

A convoy of trucks passes him, badly splashing him. Moments later six figures go by on motorcycles. Gunther squints at them through the driving rain and does a double-take. They look like German soldiers.

I decided that it was not a cop-out to cast Gunther back in time this way. I remembered an earlier story on television in which Joan Crawford, in the lead role, went through a time warp while in a library. The character of Richard Collier, in *Bid Time Return*, by Richard Matheson, is obsessed with going back to the year of 1912 and programmes his mind to do that. Finally it just happens, and his room in the Grand Hotel simply turns into a 1912 room of the same hotel. If a fiction writer can handle it skilfully enough, the reader will accept a time travel solution. H.G. Wells proved this in his great novel *The Time Machine*. A suspension of disbelief is thus achieved.

He runs towards the sound of it and reaches a corner restaurant with outdoor tables. A young man with a gun in one hand dashes by him, and Gunther asks what has happened. The man yells back over his shoulder, in German, that two members of the resistance were just wounded and then taken away by the Gestapo.

Gunther thinks he heard wrong. He understands German but is confused by what the man yelled. He looks for a telephone to call Teresa, but all the shops are closed, and there seem to be few people on the streets. There are not many lights on anywhere, and he cannot understand what has happened.

At a corner restaurant, just to the left, he sees a telephone built right on to the wall. He cannot get Teresa, and a voice tells him 'there is no such number'. Gunther slams the receiver down and starts running up the street. Just as they turn the corner ahead of him, coming his way, he sees two Nazi storm-troopers. As they draw closer to him, he spots without doubt the black swastika on their arms.

Gunther finally realizes he has gone back in time to the Berlin of the Nazis, the Third Reich, and Hitler. His mind questions it, but he cannot doubt what his eyes have seen. It seems like a dream. He wonders if he is losing his mind.

He runs back the way he came, but the troopers are after him fast, yelling orders for him to stop as they run. At the other end of the street, two German soldiers on motorcycles turn the corner and head toward Gunther. He is cut off either way he goes.

Not sure what to do next, Gunther hears a car screech through a side alley only yards from where he is standing. A man jumps out and yells at Gunther, motioning for him to get to the car. Gunther sees that it's the man from the corner restaurant and climbs into the car. The car backs out of the alley and speeds away.

One key goal of a fiction writer is not to bore the reader. I wanted an action scene when Gunther first comes out of the library, and this series of events seemed to fit. I knew, too, that it would be the resistance members who would save him from being caught by the storm-troopers. It was necessary to do considerable research regarding the resistance, and it proved to be helpful in planning the events.

Gunther is taken to the hideout of the resistance and meets the key leaders. He shows his passport, driver's licence, and various credit cards. He is asked why he showed up so quickly after two resistance members were wounded and taken away.

The resistance leaders tell Gunther his licence and cards could be forgeries, and they don't understand what credit

cards are. The man from the corner restaurant does not think he's a spy and asks Gunther what year it is. The others laugh.

They tie Gunther up, and he has time to think. He knows now for sure he is back in time. He comes alive with a new sense of purpose. His time in the past is limited, and he is aware of it. He realizes he has the chance he has thought about for many years – the chance to kill Hitler and save thousands if not millions of lives.

Later he pleads to know what year it is, and Hans, the resistance leader, tells him it is 6 July 1944. Gunther is excited and tells Hans he is on their side. He offers to take part in any raid or attack as a test. Hans leaves and returns with a stunning brunette of about 35. She's wearing commando clothes and has a gun in one hand. She is Ursula, the daughter of a true German patriot, who was one of the first killed by the Nazis. Hans says she is good at picking out spies and helped the resistance find two other traitors in their ranks a few years earlier.

Every fiction writer knows that a novel without romance is like a cake without the icing. I wanted to bring some romance into the novel, and so I introduced Ursula as the real resistance had many women in their ranks who risked their lives to fight the Nazis.

Ursula says, 'I can tell a spy by the eyes.' She studies Gunther's face and finally speaks: 'I'm not sure about this one.'

Some resistance members want to shoot Gunther, but Hans says they must have proof first.

Hours later, Gunther tells Hans he has certain secret information that will prove he is not a Nazi spy. He tells them that a top secret plan has been in the works for months, to try to kill Hitler in the next few weeks. Gunther says he will gladly volunteer to be the one who kills the Fuhrer. He asks for pencil and paper and prints a single word on it – 'Valkyrie'. He hands it to Hans, who shouts something and runs into the other room. He orders someone to leave and make a phone call.

Twenty minutes later, they cut the ropes from Gunther and

help him to his feet. Ursula brings him some food and smiles at him. She says the eyes never lie and his eyes made her unsure he was a spy.

Hans explains they have no direct role in the plot to kill Hitler, but they know about 'Valkyrie' and the forthcoming plan. Hans does not believe Gunther will be allowed to help but will take him to meet a man involved in the plot.

The next morning Gunther says he has a plan of his own to kill Hitler and asks if they can find out any of the Fuhrer's movements for the next week. Hans replies that due to previous attempts, Hitler now changes his routine and schedule often.

I next decided that this story needed an action event or raid by the resistance. Too much conversation by characters remaining in one place can bore the reader, and I tried to come up with events to increase the pace and interest.

Gunther's knowledge of history echoes in his brain. He knows that Hitler's death even in July of 1944 would save millions of lives. If he could be taken out before or on 20 July, the plan known as 'Valkyrie' will be saved.

History proved that 'Valkyrie' had failed. The explosion at the conference headquarters in East Prussia left Hitler with only minor injuries, though it killed one and wounded several others. The planned takeover failed. Hundreds were executed. If the bomb at the conference in East Prussia could be placed closer to Hitler, or if some other, more sure, way of killing Hitler could be found and acted on, the course of history could be changed.

I knew that my lead character needed to meet or come near to Count Berthold von Stauffenburg, a leader of the conspiracy against Hitler. Those close to Stauffenburg were eager to recruit good people and Hans introduces Gunther to an assistant of Stauffenburg.

I wanted more conventional action at this point, so I had Gunther go on a raid with Ursula, Hans, and several others.

When they arrive at the castle, it is dark with no moonlight. Hans, Ursula, and six others climb to the roof of the castle and then enter through a high window left open for them by one of their own men, a spy, planted earlier inside the castle in the uniform of a Nazi captain.

It goes well, and eight Nazi officers are killed. The resistance commandos get away with no losses, but Ursula sprains her ankle.

Increasingly attracted to Gunther, Ursula asks him to tell her about America. Hans suggests they go to her cabin in the mountains (owned by her family for some years) to rest and stay off the bad ankle. One of the group drives the two of them to the cabin, going a strange way to avoid being followed.

From the above account of this novel's action, you get a specific, and hopefully a clear example, of how a fictional dream can develop. You also know now why I plotted and developed this novel. A fiction teacher once said that 'fiction is people caught up in some engrossing story, crisis, or events beyond their control.' The resistance members were horrified at the evil subjugation of their country and fought it as best they could.

I believe also that fiction involves a lead character who wants to do something, in whom is a specific goal or objective.

Behind every novel is a person telling us a story. It is the action of the characters in a story that holds the reader, that reflects real life . . . or often seems to in different ways.

4 Experience

The main reason that many writers do so little writing in their early years is the lack of experience – not experience in writing but experience in living, in life itself. Some of the best advice for any writer is to become immersed in experience and contemplate that experience. Think about it. From the nucleus of that experience will come ideas for plots, intriguing situations and believable characters.

Jack London knew the north of North America and the great outdoors, and what it was like to cover great distances in the snow. This experience served him well in his fiction. Margaret Mitchell grew up hearing all manner of stories about the Civil War, what Sherman had done to Atlanta, how he burned his way to the sea and how difficult it was when the war had ended with the south the losers. All of this was a great help in fashioning her novel about the old South. 'Look no more for that time, that era, for it is gone with the wind.'

John Gardner, in The Art of Fiction, advises writers to crawl inside the characters they create, to see life and the world through the eyes of each character. By learning to do this skilfully, the characters will not be cardboard, flimsy, and wooden but will come alive on the printed page.

Before starting my Second World War novel, I saturated myself with the period from 1939 to 1945. I tried to immerse myself in the era of the Third Reich and understand how so many in Germany were caught up in the hysteria of the times. Seeing

newsreels of Hitler speaking and films about the suffering, and learning about people who survived, was all helpful. From my immersion in what was going on daily in that country came my lead character and plot. The human mind is strange and wonderful. One night I saw, in my head, some of my characters and realized what each one was trying to do or wanted to do.

I discovered that if you immerse yourself in the lives of your characters, the twists and turns of your plot will become evident. By seeing, walking and living through my characters, I was amazed to learn a basic truth about plotting and the creation of fiction: immerse yourself enough in the lives of your characters and see life through their eyes, their positions, views, opinions and actions, and some of your characters may well begin to whisper in your ear and tell you what they want to do. This does not happen often, but when it does it is like an occult experience.

Let us now return to the Berlin of July 1944 and Gunther's situation. Notice how this entire plot, this sequence of events, could naturally emerge from contemplation of those terrible times in Germany. Yet keep in mind that this is merely one plot. A variety of others might have come to the fore with different writers at the helm.

> After two happy days in the cabin, Ursula tells Gunther that he reminds her of a man she was in love with ten years earlier when the Third Reich was getting started. This man believed in Hitler and Ursula had broken their engagement to join the resistance later and fight everything the Third Reich stood for.

When writing sexual scenes, a fiction writer has two basic choices. You can write explicit scenes or by using a skilful choice of sentences you can suggest it and let the reader do the rest. One sexual scene in *Room at the Top* was handled very effectively without the need or use of explicit words and phrases. Through the skilful use of suggestion, there was no doubt in the reader's mind what had happened.

Once I had Ursula and Gunther back at the resistance hide-

out, I decided to get Ursula in danger via a Nazi major who would immediately be suspicious of her absence.

Before I could continue with the story, I had to get to know the characters of Ursula and the Nazi major better. I tried to immerse myself in their lives, see things from their vantage point, and think what might have happened to them during their previous years. This took time, and it delayed my progress on the novel but this is a case in point where elaborate character sketches can be of great help to a fiction writer.

> Ursula returns to her job at the cafe. Just before noon, the Nazi major, Kruger, arrives with two soldiers. He points out Ursula to his men and orders that she be brought to his car.
>
> Kruger questions her in his car and asks about her limp and where she has been for two days. Kruger wants to know where she lives, and she gives him an address. She now lives in a room not far from the café. Kruger says if she would be nice to him he could get her a much better job. He makes a pass at her, grabbing her with both hands. She struggles free and pushes him back. Angry, he orders his two soldiers to hold her, and they pin her arms back. He then hits her several times in the face and ribs.

I decided that Hans was the logical character to come to Ursula's aid because he works with her in the café. Hans runs to the car and tells Kruger there is a phone call for him. With Kruger's attention diverted, Hans eases Ursula away from the car telling the soldiers she is needed in the café kitchen.

I then decided to exploit this scene for more dramatic power. Half-way to the café telephone, I had Major Kruger change his mind.

> Kruger snaps that the phone can wait. He returns to his car, and pulls at Ursula's arm, trying to get her away from Hans. Kruger spins Ursula around and pulls her close to him. Ursula spits in his face.
>
> Kruger reacts with fury. He orders them to hold her and

then beats her a second time. Kruger then shoves her to the pavement, climbs into the back seat, and one soldier drives the car away. Ursula lies there in front of the café.

Hans and another resistance member drive Ursula to the home of her uncle Carl in the countryside not far from Berlin.

Days later another resistance raid is scheduled and Ursula arrives wanting to take part in it. Gunther and Hans vow that Major Kruger will pay for what he did to her.

All goes well on this daring mission, and the resistance blows up a train carrying reinforcement troops to an area near the Reich frontier.

Next in the story I wanted a more dangerous mission for the resistance to attempt. I believed this would heighten the suspense. To keep the reader wondering what will happen next is part of the art and challenge of fiction.

Three days later, Ursula and Hans are working at the café. Four Nazi officers are having lunch, and Ursula overhears something important. A meeting of top Gestapo leaders is to be held the next night in Ursula's former family home, which had earlier been taken over by the Nazis. A man named Lantz, who was mainly responsible for the arrest and execution of Ursula's father during the early days of the Third Reich, is expected to be at the meeting. The resistance members plan to surprise the Gestapo meeting and kill everyone there.

At this point in the story I felt I needed to insert what I prefer to call Murphy's Law. This law affects all humans and states that 'what can go wrong will go wrong'. Murphy's Law can strike at any time and in peace time or war. I thought it would make the entire novel seem more real and believable. Things do not go perfectly in real life, and the same is true (or should be) in fiction.

The attack does not go well. The resistance gets into the house where the meeting is being held by wearing German officer uniforms and pulling up to the house in an official car stolen earlier. Five important Gestapo leaders are killed and three

wounded. Ursula recognizes Lantz in the group and shoots him first, but more Gestapo aides and guards have been assigned to the house than the resistance expected, and they quickly respond to the gunfire.

While getting out of the house and away in the same car, Ursula and three other resistance members are killed.

After this train explosion and attack on the Gestapo meeting, the Nazis crack down hard. Anyone remotely suspected of being in the resistance, or even sympathetic to them, is arrested. Gestapo leaders put a curfew into effect and watch the café closely. It is more dangerous than ever for the resistance to hold meetings.

At this point I wanted to show the reactions of Gunther, Hans and the other resistance members to Ursula's death. All of them feel badly about it, and Hans swears the Nazis will pay. Gunther's obsessions grows worse, and he fails to show up at what few meetings the resistance is able to have.

Gunther steals a car and parks it near the café out of sight. He hounds the area. One morning Hans spots him at a table and Gunther asks Hans, who still works at the café, to seat Kruger at a back table the next time he shows up there.

Two days later Kruger and his aide walk into the café Gunther watches them enter from across the street. He sees Hans usher them to a back corner table. Gunther immediately goes to Kruger's car and pulls up the bonnet of the car. He knows little about cars, but he pulls several wires out.

Kruger and his aide come back to the car. The aide turns the ignition, and the car sputters but will not start. The aide checks it and begins trying to connect the wires. Kruger yells to get help from the café. The aide rushes into the café, and Hans takes him in the back to get some tools. Moments later, Hans comes out of the café and crosses to Gunther's car.

I wanted to extract all the action and dramatic power possible from this scene for I planned several versions of it before choos-

ing the one I liked best. I urge every fiction writer to explore all the options, choices, and potential dramatic courses that a given scene may hold.

> Gunther rushes to the side of Kruger's car. He yanks the back door open and slams a gun into Kruger's face, ordering the major out. Hans drives across in Gunther's car having detained Kruger's aide.
> They drive to a wood and Gunther escorts Kruger into the wood. He tosses the gun aside and challenges Kruger to fight him over what he did to Ursula.
> The two slug it out with Gunther beating Kruger by far. Desperate, Kruger makes a wild rush for the gun on the ground and Gunther stops him just in time, knocking him back over a long horizontal tree trunk. Kruger's body flips over the trunk, snapping his neck like a twig. Gunther examines the crumpled form, sees Kruger is dead, and drags the body behind some thick shrubs. Hans and Gunther then ditch the stolen car.

My next key decision was made when I concluded that it was time to move Gunther closer to a chance to kill Hitler. I was not sure how to do this, but once again I turned it over to my subconscious mind. The answer came in a few days right out of the blue, and I felt sure I knew how to proceed. I took notes during these few days and planned alternative scenes. An enormous help to a fiction writer is the ability to visualize the continuing action, the storyline, as if you are seeing it acted out on a stage. I believe the two films I did earlier – plus some television and stage experience – helped me a lot in the visualization process.

> The Gestapo trace the major's disappearance to the café. Hans had hit the aide over the head, but it had not killed him. The aide came to and fixed Kruger's car, noting the major was not in it. All who work at the café are picked up the next day and brought to Gestapo headquarters.

Hearing the news and thinking that Hans may also have been at the café and arrested, Gunther watches Gestapo headquarters from a block away. Suddenly, with soldiers and Gestapo on both sides as escorts, six cars pull up to the headquarters. The back door of the middle car opens, and Hitler himself steps out and goes into the building.

It was here that I had my lead character go a bit crazy with excitement and the sheer pressure of his obsession. Gunther cannot believe his eyes and rubs them. He watches another ten minutes and then leaves. He is wild with excitement and talking to himself: 'He's here in Berlin. My God, I've got to get to him. It may be my only chance!'

Gunther goes to the resistance base and tells Hans and the others. Word also reaches Berthold von Stauffenburg. One of the conspirators also spotted Hitler and relayed the information to Stauffenburg's assistants. The colonel is surprised and upset to hear that Hitler is in Berlin. The plan of the conspirators is for a bomb to be planted at a conference meeting at Hitler's East Prussia headquarters on 20 July. It is now 15 July. If Hitler remains in Berlin, the plans will have to be changed.

Colonel Stauffenburg calls an urgent meeting of the main conspirators. He concludes that Hitler is again changing his routine daily for safety reasons. That or else he is in Berlin for some express purpose. Stauffenburg is worried that Hitler has been told about the conspiracy, and orders the other conspirators to find out how long Hitler will be in Berlin and why he has come.

In any kind of thriller, or war background work of fiction, the more suspicion and intrigue the writer can get into the story the better. Fortunately, the plot to kill Hitler already held plenty of both, and so I gradually weaved my own storyline into the true, historic one, the Valkyrie plan on which Colonel Stauffenburg and the other conspirators staked so much . . . including their lives.

5 More Happens than Meets the Eye

This is a good place to bring out an important truth about fiction and especially novels: there is often more going on than readers may realize. Take *The Strange Case of Dr Jekyll and Mr Hyde*. Bea's worry about Jekyll adds to the suspense, and so does the increasing fear Ivy has that Hyde will come back into her life.

In other words, a novel can have one or more sub-plots going on at the same time as the main story line. 'Counterpoint' is defined as 'the art of combining melodies' and also as 'the texture resulting from the combining of individual melodic lines'. This word could also apply to the art of combining fictional plots.

In Ayn Rand's *The Fountainhead*, there is not just the main story of Howard Roark's desire to be loyal to his own architectural integrity. There is the story of his relationship with the woman he loves and why he has to wait years before she comes to him ready to marry him. Roark's friendship with the owner of the *Daily Banner* is another story going on at the same time. These different layers enrich the novel as a whole and enable the reader to experience life, and the lead character's world, more fully.

Gone with the Wind is a strong example of this 'counterpoint' idea. The novel is not just about what happens between Scarlett and Rhett. There is Scarlett's obvious obsession with Ashley, and there is also her determination to survive after the Civil War. In

one of the most dramatic scenes, Scarlett vows that whatever she must do to live, to go on, whether it be 'to lie, cheat, or kill', she will do it. 'I'll never be hungry again,' she swears, and the reader is convinced.

Bid Time Return, by Richard Matheson, is another case in point. The lead character, Richard Collier, becomes fascinated by a portrait of an actress of an earlier time. He cannot get his mind off her. Another part of the story is his determination somehow to go back to the year 1912. Accomplishing this feat (even in a fantasy) takes patience and an incredible amount of persistence in applying the uncertain techniques. Once Collier is back in 1912, he encounters the increasing hostility of the actress's manager.

Semaphore by G.W. Hawkes is a novel set in the Carolinas. The main character is a boy, a mute, who has the ability to see the future. You can imagine how much more is going on in this story than meets the eye. The more complicated a lead character is, the more likely there will be different layers of the story unfolding.

Let us now return to the unfolding plot of Burt Gunther in the Berlin of July, 1944. Obviously, Hitler told none of his key generals why he was in Berlin, and this fact has the resistance members stumped and nervous. You will remember that I had decided to throw a 'Murphy's Law' into the story at this point. If things go too smoothly in a fictional work, the reader will tune out and lose interest. A fiction writer must continually surprise, fool, and intrigue the reader to keep the person turning pages.

> Gunther and Hans situate themselves not far from the front of the Gestapo building. Two other resistance men watch the back exit and a car with two resistance members sits just down the road.
>
> Shortly after dark the next night, Gunther and Hans see three Gestapo men come out of the building. Walking between them is Hitler, who gets into a waiting car and is driven off. Gunther and Hans helped by other resistance members follow the car.

As a fictional tale unfolds, the writer should let the reader know what is happening with the weather, national or international events taking place, and other news. This adds to the total impact of the work and makes it more interesting for the reader.

Following my own advice, I decided to describe what the weather was like at that time. A light rain is falling, and this makes it harder for the Gestapo to notice they are being followed. On the other hand, it also cuts down on the visibility needed to keep the car in sight.

> Hitler's car finally arrives at a handsome country home some 30 miles from Berlin. Hans turns on to a side road where they cannot be spotted. Gunther watches Hitler go inside the one-storey house. Then the car turns around and drives back the way it came. Gunther thinks this is an ideal chance to kill Hitler. Hans is suspicious that Hitler is not more closely guarded and better escorted.

I felt at this point in the novel the reader would be wondering if Gunther will be able even to get close enough to make a try at nailing Hitler. Author Arthur Gladstone advised fiction writers 'not to offer anything they had written until they are satisfied with it themselves.' The characters should develop naturally in his view and not be forced. I debated with myself at different points as to whether I was forcing my characters. I sought also to avoid contrived solutions. Still, I felt that Gunther's obsession would hound him even more once he realized how close he was moving to an actual chance to eliminate the dictator.

While writing this section of the novel, I thought it would be more suspenseful if Hans and Gunther are unsure what they are walking into. I slowed down the scene, at least the pace of it, and believe it added to the overall effect.

> After a twenty minute wait, Gunther and Hans creep up to the back of the house. As quietly as possible, Hans breaks a back cellar window, and both of them slip inside. Gunther pulls out a flashlight, and the two make their way to the stairs. They move

down a main hallway when suddenly they hear a glass smash to the floor and instinctively wheel around. They move towards the sound until they come to a large kitchen. Slowly peering around the corner, they see a man who entered the house with Hitler. He is seated and pouring a drink into a fresh glass.

Hans stays there to watch the man in the kitchen while Gunther moves towards the other side of the sprawling house. He hears music playing. He finds the door where the sound is coming from and decides that Hitler must be inside. He pauses a few minutes before knocking on the door.

I thought, hopefully, that the reader would be very anxious for Gunther to get on with it and open the door, so I purposely had him pause for a few minutes. I believe this increased the suspense and expectation. After all, the reader does not know for sure what Gunther will find inside.

Gunther knocks on the door, and a voice from inside responds in German: 'What is it?' Gunther knocks again. In a few moments, the door is unlocked. Gunther pushes Hitler back inside the room and grabs him around the throat. Hitler elbows him in the stomach and somehow breaks free, quickly making a wild rush for a revolver lying on a table. Gunther gets there before the gun can be fired and twists Hitler's arm until he drops it. Hitler grabs a knife and makes wild thrusts with it but Gunther dodges them easily and lands a right cross on the dictator's jaw. The knife flies across the room.

Hitler picks up the nearby table and throws it at Gunther. Then he runs headlong through the one window of the room, crashing to the ground outside the house in a sea of broken glass. Gunther follows him and tackles him. After another struggle, he strangles him. Convinced he has killed him, Gunther regains control of himself and slumps to the side of the lifeless body.

I did a lot of re-writing for this fight scene. Fictional fights must read well and sound believable. One of the greatest fight scenes

takes place in the novel, *Shane*, perhaps the best classic western of them all. A writer must plan a fight in detail and know exactly what will happen unless of course it is a free-for-all with every man for himself in a crowd fight.

At this point I wondered if the reader would believe that Gunther had really killed Hitler. It appeared that he had done so, but would the reader be suspicious? Was it too easy? Why were there so few guards around him? I believe it helps a fiction writer to get inside the mind of your reader from time to time. This can help in the plot development and actual writing of fiction. I kept visualizing this fight scene over and over, making a number of changes before I was satisfied with it.

> Hans comes running from the house to Gunther lying on the ground. A loud siren sounds. They run for their car and speed away.
>
> Word comes the next morning that the man Gunther killed was not really Hitler but a double, a look-alike actor being used by the Gestapo as a fake, a decoy, to divert the Reich's enemies and to protect the real dictator's life even further.
>
> Meanwhile, Stauffenburg and the conspirators have learned the truth for themselves. Suspicious from the moment he heard Hitler was in Berlin, Stauffenburg checks.

Gunther could have easily gone over the edge when he learns he did not get the real Hitler. I thought about this reaction, but I decided instead simply to let him be stunned and upset to discover he had fought with a clever German actor. I next decided it was time to focus on the 20 July plot to kill Hitler as led by Stauffenburg and the conspirators hoping to overthrow Hitler and the Reich.

A lot of research was necessary to learn what really happened that day in East Prussia, and I found it fascinating. Stauffenburg and the conspirators deserve credit for a dangerous try to eliminate Hitler and take over power in Berlin. Stauffenburg was appalled at what Hitler was doing to Germany and wanted to bring sanity and order back to his country.

It is now 17 July, which was only three days until the Stauffenburg plan was scheduled to take place at Wolf's Lair. At the precise time of the planned killing of Hitler, power is to be seized in Berlin. Everything must go according to the plan, and all the preparations for the takeover are set for 20 July and not until then.

> Gunther knows that the bomb failed to kill Hitler, and realizes that he must do something to ensure that the plot will succeed. He must make certain that the Fuhrer dies on 20 July, or most of the key conspirators will be quickly arrested and shot, which is exactly what history says happened. He manages to talk Stauffenburg into letting him fly with the conspiracy leader to East Prussia. Gunther tries his best to persuade Stauffenburg to put two bombs in the briefcase (or a more powerful single one) and says he fears the one bomb will not do the job.
>
> Halfway to Wolf's Lair, Hitler's East Prussia headquarters, Gunther realizes he has no choice but to tell Stauffenburg that he comes from the future. He tells him about his strong knowledge of history, and says that the Valkyrie plot is doomed to fail. Stauffenburg is bewildered and angry, but he listens closely.

In my plot development, I reasoned that Stauffenburg could not believe a 'time-traveller' premise and that his natural reaction would be that Gunther has lost his mind. He humours him first, but once they land he pulls a gun and ties him up. This naturally leads to one key question. Can the past be changed? Could Gunther have really changed it.

> 'I can't take a chance on our plan being ruined by a lunatic. From the future you said? You must take me for a fool. I think you really want to help us kill Hitler from what Hans told me, but I must go alone.'

I thought a lot about a character trying to change the past, and that led me to think about the plot of *It's a Wonderful Life*, the Christmas film that is shown every year. The character of

George Bailey gets his wish and sees what the world would have been like without him. Clarence, his guardian angel, shows him the grave of his younger brother, Harry Bailey, and George argues that Harry saved the lives of everyone on board a ship when he shot down enemy planes. Then Clarence makes the key statement: 'Harry Bailey wasn't there to save all those lives because you [George] weren't there to save Harry when he slipped on the ice as a boy'.

The *Wonderful Life* example backs up the idea that the past cannot be changed ... no matter how badly one may wish to change it.

Before entering the conference building, Stauffenburg quickly lights the bomb fuse and closes the briefcase for the last time. He returns to the building, goes inside, and places his briefcase under a table around which Hitler and his military advisers are to gather. A number of them are already there awaiting the Nazi dictator's arrival.

The pilot goes back to the cockpit, and Gunther is alone. He works feverishly to get the ropes off his hands. With his hands behind him, he moves his wrists back and forth for some ten minutes, finally cutting the ropes.

> Taking a hand grenade he had brought with him, Gunther slips out of the plane and heads towards the compound. He tells the guards that he's an aide to Colonel Stauffenburg. Gunther is dressed in the right uniform and also has the right papers (provided him earlier by resistance members).
>
> Stauffenburg leaves the meeting on a pretext and makes his way slowly back to the plane. It is 12.30. The bomb is set to go off at 12.42.

My plan was to get Gunther to the exact building where the bomb was placed, and I believed this would increase the suspense and dramatic tension of the story. Gunther arrives there with the guards. One of them speaks to another security man on duty at the door. Gunther's papers are checked again, and the word comes back from inside that Stauffenburg is not

there. It is now 12.37. I decided to give the time every few minutes, knowing that, too, would increase the suspense.

> Gunther asks if he can wait inside for Stauffenburg. Since he has been cleared by several guards, they let him enter the building. One guard tells Gunther that he will have to stand at the back of the meeting-room. Gunther glances at his watch. It is 12.41. The bomb is about to go off in less than a minute. Seconds tick by. As he reached the meeting-room door, with no guards in sight, Gunther pulls out a grenade. Only twenty seconds are left now.

I had to plan what would happen to the second. I re-wrote this scene a number of times until it had the pace and suspense I wanted.

> Gunther pulls the grenade pin, opens the door, tosses it towards the table section where Hitler is standing, slams the door, and runs. There is a loud explosion and then a lot of yelling, but no second explosion follows. Gunther dashes for the plane, but he does not get far. In less than four minutes, German soldiers on motorcycles, and in three cars, cut off his direction. He is captured and led at gunpoint to a car driven by the Gestapo. He is pushed into the back seat, and the car pulls away.
> Meanwhile, Stauffenburg hears the explosion, assumes that Hitler is dead, and bluffs his way out of the compound. He reaches the plane, flies back to Berlin, and orders the rest of the conspirators to put the 'Valkyrie' plan into effect at once. The special 'Valkyrie' signal goes out in Berlin and Paris, and the conspirators gather at the Ministry of War. A secret code word for starting the plan is sent to all military district head-quarters. Orders to take power are sent out over the teleprinter. However it has been an unlucky day for the conspirators. Gunther's grenade did not go off, and the bomb leaves Hitler with only minor injuries.
> Counter-measures are immediately started, and counter-

orders from East Prussia cross those of 'Valkyrie' from Berlin. The conspirators try to move ahead with the plan to take power, in spite of Hitler's survival, but the military leaders, rather than side with the conspirators, choose Hitler. In just a few hours, the conspiracy is completely crushed.

In planning and writing this fictional work, I knew I had to stick to the historical facts. Stauffenburg and his fellow conspirators made a gallant attempt to eliminate Hitler, and it might have worked had the bomb Stauffenburg used been a more powerful one – or if it could have been placed closer to Hitler under the conference table. I weaved Gunther being on the scene with his obsession into the actual, historic 'Valkyrie' plan. Since Hitler survived, the grenade thrown by Gunther could not have killed him. The past facts could not be changed – even by a time traveller determined to kill the Nazi dictator.

A blood-bath followed this plot to kill Hitler. Hundreds were executed, and that same evening, Hitler spoke over the radio from East Prussia, reassuring the German people that he was still alive. He made a point of saying that he was 'destined by fate to continue to lead them'. Hitler promptly tightened his control. Anyone thought to be connected with the conspiracy was thrown in jail or killed. Some took their own lives rather than endanger others. Gunther comes close to being shot, too, but Gestapo leaders want to question him further to learn who else was in on the plot. He is flown to Gestapo headquarters in Berlin and is questioned there for many hours in between periods of torture. The Gestapo go through everything in his wallet and are puzzled by the date on his driver's licence and other documents. Some want to kill him. Gunther uses his knowledge of medical and scientific breakthroughs since the end of the war and the Gestapo believe that Gunther may be of value to them in winning the war.

While being transported to a prison by three Gestapo men, Gunther manages to escape. He tries to make his way back to the resistance hideout but is spotted by a German patrol.

German soldiers are about to capture him when he suddenly disappears from their clutches. He has returned to the present, but he does not realize it yet. He only knows there are no more soldiers or Gestapo after him. He seems to be in the rear area of some large warehouse. It is dark. He starts walking towards some lights he can see in the distance. The streets are deserted. His watch has stopped, but he is sure it is late and probably close to midnight.

I tried a number of endings for the novel and did a lot of re-writing until I got one I liked. No fiction writer should settle for the first ending that seems to suggest itself. There may be a better one. It can be helpful to think about it for several days and to explore other possible endings before making a final decision.

Suddenly a car pulls up from around a nearby corner. Two men push Gunther into the car and speed away. He has come back to the present but, unfortunately, he is in East Berlin.

What I was trying to convey to the reader was the fact that Gunther, the lead character, was still not out of danger. He was back but still not safe.

East German officials question him for many hours and refuse to let him sleep. He has no papers at all on him now, and they think he is a spy from the West.

After a week of this treatment, Gunther's mind snaps. With everything Gunther had gone through, both before and after his return from the past, I felt the reader would accept this result. His constant obsession, too, had given him no rest, and the fact he had failed to eliminate Hitler ate away at him like an acid.

With his mind snapped, Gunther begins to rave about the Third Reich. He demands that he be released and claims he is an aide to Colonel Stauffenburg. While being taken to his cell, he kills a guard, runs from the building, and makes his way

down the street. Then he jumps on the back of a passing truck.

Whilst trying to see where he is Gunther falls out when it turns a sharp corner. He is not aware of it, but he is now only 200 yards from the wall dividing East and West Berlin. The truck would have taken him to West Berlin if he had not fallen from it. Guards at the wall spot Gunther wandering around and keep a close eye on him. Still crazed, he runs up to them shouting 'I am an aide to Colonel Berthold von Stauffenburg. Drive me to our office at once.' One of the guards picks up the telephone and a car soon pulls up to the wall. Gunther runs out parallel with the wall, trying to find a break in it where he can slip through. There is none. The car reaches him, and three men get out and move towards him.

Gunther begins climbing the wall. The guards shout a warning and fire over his head. Gunther screams again: 'I'm an aide to Colonel Stauffenburg. The Fuhrer will hear of this.' The men from the car yell that he is not to be shot, but the guards at the wall do not comprehend and fire again. Riddled with bullets, he slowly sinks down into a heap against the wall. His strange obsession has finally ended.

From the above plot, you can tell that more is happening than meets the eye. When Gunther's story opens, it would appear he is just another college professor teaching a class. But this is deceptive, and the reader quickly learns about the obsession that will lead him to a worthy attempt to assassinate Hitler and thus save millions of lives.

A fiction writer invents. Being a creator, you must learn what the undercurrents are in your plot, in the story you tell, in the sequence of events you unfold. You do not drop in on the lead character and find him or her isolated from everything that has happened up to that point. You must learn where the person is coming from, what their goals are, and what events have taken place prior to your focus on that person.

6 Outlines and Plot Points

Sooner or later most fiction writers come up with their own ways of creating a plot. Many writers, for example, do an outline. Some will even spend six months or the better part of a year working on an outline. Others take a different view; they do not wish to spend all their energy on an outline, with little left for the actual novel. Some writers skip the outline stage and seem to have an amazing ability to juggle everything in their minds while writing. Let us consider some of the advantages and disadvantages of using an outline.

A promising outline or synopsis can sell your novel. There is a number of writers who have sold their books before writing a word. They did it with a strong and promising outline. What this means is that if the outline or synopsis you create shows enough promise for a finished book, you will know the happy feeling of selling your work. It is true that many editors will want to see more before reaching a decision – perhaps a few chapters along with your outline. Never forget, though, that some authors sell their books with just a strong outline-synopsis. But obviously, your outline must be a good one. You will learn with experience that requirements vary according to the editor and publisher. Some editors will make a decision based on an outline alone. Others need an outline or synopsis, and a few chapters.

The author of *Jaws*, Peter Benchley, sold his very first novel on the basis of a one-page outline that described his idea for a

book about a great white shark that terrorizes a Long
resort. Benchley had briefly mentioned his idea to a Doub
editor, who asked to see the idea expanded. Benchley descri
it on paper, and Doubleday liked the outline enough to take ₁n
option on seeing four chapters. *Jaws* became publishing history
and joined the coveted list of all-time best-selling fiction. I
believe this is a classic example of the value of an outline or
synopsis.

Whether or not you like the idea of an outline, bear in mind that some kind of plan for your novel is usually better than none at all. For one thing an outline can build enthusiasm.

Never forget the power of enthusiasm. It can mean a great deal to a writer. Staying enthusiastic about your book is vitally important to seeing it through to completion. Many works of fiction die stillborn because they are abandoned in midstream or never finished. Enthusiasm can work like a fuel source. It keeps you hanging on, making decisions, writing, thinking and rewriting until your work is completed.

Taking the time and effort to create a strong outline or synopsis will have a double payoff for you. It gives you a plan for the novel and it creates enthusiasm for completing the project. 'Man succeeds by bits and pieces' is an old cliché, but it is still true. Most of us need to see the next step in our journey towards a goal. An outline shows an author that next step.

It is often easy to outline an article in your mind, but a novel or fairly long story is more complicated. Full-length books call for a basic plan, a clear blueprint that shows how you intend to reach the end, to complete the project. Many people remark that they could write a novel and that they intend to do it some day. Most of these would-be authors are dreaming, and yet many of them would be amazed at what they might accomplish if they took the time to develop a strong fictional idea and then do an outline or synopsis. The task is a lot less daunting.

Basically, doing an outline-synopsis makes plotting easier. Wouldn't you rather have a map, a plan for a work of fiction, when you sit down to start work? Without it you would have to juggle everything from the first word. Maybe some few gifted

writers can work without a plan, but others would be lost without one.

Just what goes into an outline? The best kind gives a clear idea of what happens in each chapter. This way the entire work can be considered and evaluated. Some writers discover that they hate the outline they have halfway finished. What they may do at this point is tear it up and start all over. They go back to square one. Painful though that can be, I do not think that scrapping a bad or confusing outline is as painful as losing an entire manuscript, which has happened to some writers.

What else goes into an outline? Some include the theme and plot, along with descriptions of the main characters, the conflict of the story, how the complications build to a crisis and resolve in a climax, and how the entire story is brought to an end. An outline may run from a few pages to twenty, thirty, seventy-five or more. If it gets too long, however, it may defeat its purpose. Short stories may need just a short outline or none at all. Keep in mind that some so-called short stories turn out to be rather long ones. If so, an outline in most cases can only help.

To see both sides of the picture, let us take a look at why outlines are disliked by a number of fiction writers. Some of these reasons may be similar to each other, because different writers state their objections in various ways.

- Outlines set a limit on the creative process. The author may feel that he or she cannot make any changes once the outline has been set. This is the 'written in concrete' view; some writers simply feel that outlines, once finished, are written in stone and cannot be changed.
- Outlines are too restrictive to the mind. Writers feel locked into them, which is another way of voicing the first objection.
- Outlines are flat and cold.
- Changes are quite likely to suggest themselves while the author is writing, and so this tends to nullify the outline and render it useless or troublesome.
- The minds of many fiction writers go blank when they have to do an outline or synopsis.

OUTLINES AND PLOT POINTS

- Authors are often more stimulated by working from an opening sentence, a setting, or character introduction. The late Harold Robbins much preferred to work this way.
- Many novelists and fiction creators simply prefer to 'turn a character loose' and see what happens. In other words, they like to discover the story as they write it.
- An outline may be a poor indicator of the final book. The completed novel may turn out far better than the outline suggested. Yet editors may turn the project down if they do not like the outline. For this reason, it may be misleading.
- Some authors have found from experience that an outline of any kind short-circuits their excitement and enthusiasm for a novel.
- A writer may prefer to work from a simple A-B-C outline instead of a complicated or elaborate one. A novelist, for example, may require only a basic idea of a story problem and its solution to produce a worthy novel. An intricate outline may thus hurt the development of the book. The degree to which this is true depends on the particular writer.

The final decision is up to you. I do, however, want to pass on a method that has worked well for me and might do the same for you. Here it is: make your decision on each fictional work you do. You should be able to sense the need for an outline on certain works, for others you may not need an outline. Experiment with the pros and cons of an outline, which is what I have done. I use an outline on some fictional works; on others I do not. You will have to try each way and see what you prefer. And remember that variations on this plan may run from a short outline to an extremely elaborate one.

Obviously, it helps to know a lot about your main characters when beginning a novel, and to have a clear idea of the setting. Some degree of planning is a must, whether you put it into a formal outline or not. You are bound to find what works best for you through experience. Keep in mind that you can always tear up an outline, change it to please you more, or do a brand new one.

One of the most helpful techniques for plotting is one I discovered some years ago. I call it the Plot Point Method. Plot points bring a story to life, propel the work forward, and keep a writer enthused about getting on with the manuscript until the last page is finished. Plot points are rising places (or levels) of interest. Consider these other advantages of plot points.

- A plot point increases the reader's interest.
- A plot point can add new suspense to the story.
- A plot point can suddenly place the hero or heroine in danger.
- A plot point can make a story more intriguing.
- A plot point can surprise the reader.

Plot points may be graphed on a chart as an ascending line of interest. You can try or test this for yourself. Simply write down the major plot points of one of your favourite short stories or novels. You will quickly be able to see if there is a line of rising interest. Draw a connecting line between all the major plot points and then study it.

Let us take the novel *Shane* as an example.

The story starts with the main character riding into the valley. One of the first plot points is when Shane stands by the homesteader when several cattlemen ride up and threaten him unless he leaves. This plot point does a lot to move the story forward, and it offers a strong hint of the showdown to come.

Another major plot point occurs when Shane first goes into town with the homesteader and his family. The boy, Joey, wants a soda, and Shane goes into the bar to get it for him. One of the head cattleman's men, Chris, begins to needle him, saying that the bar is for real men and that sidewinders like Shane should keep out of it. Shane offers no resistance, but he sizes up the situation from this experience. After he leaves, the cattlemen brag how Chris put a sidewinder on the run.

A very important plot point occurs a bit later in the story when all the homesteaders ride into town together believing

there is strength in numbers. Shane is with them, and when Joey is about to go into the bar for a soda refill, Shane tells the boy he will get it for him. Shane enters the bar, and the same man who taunted him before, Chris, is there.

Chris insults Shane a number of times, warning him to get back to the others where he will be safe. Chris calls him a pig farmer. Finally, Shane responds: 'Don't push it, Callahan.' Chris gets up and walks to the bar, and Shane tells the bartender to set up two drinks. 'You're not going to drink that in here,' Callahan warns. Shane pours the drinks over him and hits him once, knocking him clear across the barroom floor. A long fight takes place between the two men with Shane badly beating Callahan. Then the other cattlemen attack Shane. Finally, the lead homesteader hears the ruckus and comes into the bar to help Shane in the fight. Even though outnumbered, they make mincemeat of the cattlemen.

The reaction of the lead villain, the head cattleman, is to send for Jack Wilson, a notorious gunfighter from Cheyenne. 'From now on, the air is going to be filled with gunsmoke,' he vows. He now believes the only way to drive the homesteaders from the valley is to kill a few of them, which he thinks will stampede the rest into leaving.

Can you see how these major plot points draw the reader deeper into the story, increase the suspense and offer stronger and stronger hints of the coming showdown between the homesteaders and the cattlemen? Powerful plot points can be a tremendous help in writing fiction. Your outline could simply be a list of key plot points that work like a team to develop your story.

The character of Stonewall in *Shane* meets his Waterloo in a major plot point scene when he bravely faces a challenge by the gunfighter, Wilson, who has been instructed by the head cattleman to gun the homesteader but make it look like self-defence. Wilson insults Stonewall's home state, Alabama, and also says, 'Old Stonewall himself and Lee were trash like all those rebs.'

Stonewall is irked. When he tries to go into the bar for a whisky, Wilson forces him into a draw. Before Stonewall can clear his holster, Wilson, fast on the draw, guns him down.

Near the end of the novel, the lead homesteader has decided to ride into town and face the head cattleman alone. Knowing the homesteader faces a stacked deck, Shane takes on the job but has to fight his homesteader friend to do it. The showdown ending has Shane riding into town to Grafton's to face what he must. This was one of the most powerful climaxes in the world of fiction, even given the fact that it is a western novel. The reader knows very early in the story that a showdown is coming, and it is quite a strong one. Shane outdraws Wilson, the most dangerous, and still has time to get the head cattleman who has drawn on him from the side of the barroom. As he is about to walk out the door, another of Grafton's men, one of the sneakiest, is upstairs about to fire on Shane, but the floor creaks and Joey, who has been watching the shootout, yells a warning to Shane, which saves him, though he is slightly wounded.

I chose *Shane* to show how plot points work because it is such an admirable work of fiction. If you want to write novels, this is a 'must read'. Even if you have no interest in western fiction, there is much to be learned from its fictional techniques. There are excellent plot points in that story that build to an amazing suspense and excitement as Shane, alone and courageous, rides into town to rid the valley of guns and make it safe for little Joey, his parents, and the rest of the homesteaders.

When *Shane* was brought to the screen, the showdown ending was played for all it was worth. One can only wonder how many takes it took for the cameras to get the ending just right.

When Shane walks into Grafton's, the gunfighter, Wilson, is drinking coffee across the room at a table. Shane always uses only one gun, convinced one is all you need if it is used right. He stops midway at the bar and exchanges a few remarks with Grafton who is sitting at the end of the bar on the side.

He then turns towards Wilson and speaks: 'We haven't heard from your friend here.'

Grafton warns Shane, 'I wouldn't pull on Wilson, Shane.'

Shane ignores the warning. 'So you're Wilson.'

Wilson, played by Jack Palance, is now on his feet across the room and ready to draw. 'What's that to you, Shane?'

'I've heard of you.'

'What have you heard, Shane?' asks Wilson. You could cut the suspense of this moment with a knife.

Shane pauses, then straightens up, showing he is ready to draw. 'That you're a low down yankee liar!'

'Prove it,' replies Wilson.

Shane proves it and still has time to get the others, who are a little slower on the draw. Wilson crumples in a heap against the wall. Wilson was fast on the draw, but Shane was faster. The novel ends with Shane riding out of the valley, which is now safe because of him and the victory of good over evil.

Earlier, at a grave ceremony for old Stonewall, the murdered homesteader, another major plot point unfolds. This is vitally important because most of the homesteaders are scared now and determined to leave. After the burial, Shane encourages them not to give up but to stay and fight. What he says makes sense to them. It is their families that are worth fighting for, he tells them, not just their land; their children have a right to stay there and grow up and be happy. It is up to the homesteaders to have the guts to stay and fight.

But in the end, it is one man, Shane, who has made the valley safe. There are no more guns in the valley when Shane rides into the faraway hills.

The plot of *Shane* is so good that over the years other western stories have stolen parts of it. Slight differences in the new stories, and slightly different characters, could not hide the far too frequent similarities. A major reason I urge you to read this book, and study it, is because it is easily the best western novel of the last century in my view.

PART II
CONFLICT

7 Man vs. Man

And now art thou cursed from the earth, which hath opened her mouth to receive thy brother's blood from thy hand;

When thou tillest the ground, it shall not henceforth yield unto thee her strength; a fugitive and a vagabond shalt thou be in the earth.

The first death in the Bible – Cain's murder of his brother, Abel – is brought about by the envy and bitter rivalry of brother against brother, man against man. As the sons of Adam and Eve, Cain and Abel are respectively fruit and livestock farmers. When God favours Abel's offerings (he sacrifices a lamb) over Cain's harvest fruits, he explains to Cain that animal sacrifice is the more appropriate way of honouring one's God. Enraged, Cain murders his brother, twisting God's explanation by offering a blood sacrifice of his own.

Ancient Greek tragedians saw that rivalry between characters made for great tragedy. Today, we have little knowledge of how these plays came about, many having been destroyed, some eighty plays surviving from the thousands of tragedies and comedies believed to have existed. From what remains, we can see that many issues, although restricted to the belief systems of that time (over 2500 years ago), can teach us about universal themes relevant to today's world, including conflict between two people passionate about their beliefs.

In Sophocles' *Antigone*, Antigone's brothers fight one

another, and Polyneices is killed. Creon (the King) declares him to be a traitor, ordering the body to be flung outside city limits without burial. This brings the very first conflict to the play: city, Creon states, is more important than family and any traitor deserves the death penalty. Antigone disobeys, and buries her brother, pitting her wits directly against her king, and is duly sentenced to death. In this excerpt, Creon confronts Antigone having discovered her burying her brother:

> *Creon:* You alone out of all these Thebans see it that way.
> *Antigone:* They do, too, but for you they hold their tongues.
> *Creon:* Are you not ashamed that your beliefs differ from theirs?
> *Antigone:* No. There is nothing shameful about respecting your own flesh and blood.

Creon draws attention to Antigone's crime by isolating her from the rest of the city ('You alone'), contrasting her actions directly with those of the law-abiding citizens. In reply, Antigone uses the same method, suggesting that Creon is a kind of tyrant, alone in his resolute beliefs as even his people are against them. An important point to remember in this dispute is that both sides are as extreme as the other; Creon preserving the honour of his 'city' at any cost, Antigone prioritizing the dead body of her brother over her living, breathing family and friends. The conflict so far, might be represented like this:

- City vs Family
- Antigone vs. Creon
- Subject vs. Sovereign

But also at issue are the complexities of the human conditions: Creon is father to Antigone's fiancé, Haemon, who begs his father to spare her life. Immediately, another terrifying conflict arises; that of father and son. Creon, under no illusions, sees his son as a traitor, accusing him of siding with a mere woman, and becoming no better than the weaker sex, stating: 'While I live,

no woman will rule over me.' Creon's obsession to appear manly and victorious is his downfall, and his apparently honourable motives really boil down to just one: in ancient times, the king was the city, and the destruction of traitors is the same as asserting his personal power. But to do this requires a battle of father against son, blood against blood (*Haem* in Greek means blood), Antigone against her sovereign, and even against her fiancé, to fight for her dead brother's memory. Greek tragedies were thought to have been created for divine worship, and the outcome of *Antigone* is no exception. Antigone rebels against her king and fellow citizens' beliefs both because she feels that it is right, and that honouring the dead with burial is the divine law of Hades. That is why Creon, with no one but the gods to answer to, is doomed, forming the ultimate battle: sovereign vs. the gods.

> It was not Zeus that published me [Antigone] that edict [Creon's law], and . . . nor did I think that your decrees were of such force, that a mortal could override the unwritten and unfailing statutes given us by the gods.

After a final confrontation between the warring sides, Haemon kills himself next to the dead Antigone and Creon's wife commits suicide, cursing her husband. So Creon, in conflict with Antigone who represents the values of family, has sacrificed his own family for the principles of the city; by battling with his family, and indirectly the divine laws, he has won his argument, but lost a part of himself.

Conflict, and the subsequent dilemma of love set against the backdrop of civil strife, are universal themes, highly resonant in Shakespeare's *Romeo and Juliet*. Such a play would not have transcended time (and became such a hit film) had Shakespeare merely focused upon the warring Montagues and the Capulets. Gang warfare is as rife and as relevant to twenty-first-century society as it was in Shakespearean times, but without central characters with whom the audience can identify, the audience would feel isolated and unable to understand the dispute.

Shakespeare never tells us why the Montagues and the Capulets hate each other. In fact, their only reason for hatred is what their names represent; furthermore, the prologue tells us that they are basically equals in social standing and reputation.

> Two families, both alike in dignity
> In fair Verona where we lay our scene.

Meaningless conflict is suggested in the now rather well-worn phrase 'A rose by any other name would smell as sweet': it does not matter what side the lovers represent – these are two people who have found 'true love', are young and happy. Shakespeare uses the image of a rose in the same way as he uses Romeo and Juliet as central characters: the rose, a universal symbol of beauty and elegance, can be called anything, but we would still know it for what really is. Equally, Romeo and Juliet, as innocent young lovers, isolate themselves from the age-old blood feud and present an ideal with which the audience identifies. We do not, therefore, experience the Montague/Capulet conflict, but instead, our frustration at the Capulet's treatment of Juliet simulates the kind of antagonism within that conflict. It also adds to our sense of senseless waste at the tragic resolution of the play, when the Montagues and the Capulets unite in grief over their children's deaths.

The conflict epitomized in the fight between Tybalt and Romeo in *Romeo and Juliet* depended on hatred of the enemy's identity rather than their individual culpability.

The genre of 1930-40s war films clearly sets man against man in this way. Propaganda fiction demonizing the enemy added to the national sense of identity, and fiction provided a powerful tool for uniting people against a common aggressor. One of the very best examples of conflict I have ever seen, read or heard appears in *Casablanca*, a film made during the Second World War. Around the middle of the story, some high-ranking Nazi officers are having a few drinks in Rick's Café. When the senior officer tells the band to play the German national anthem, Rick hears it from the second floor. The free French hero, married to

Ingrid Bergman's character asks the band leader to play the French national anthem, and from his balcony position, Rick nods his assent. The French people seated all over the café stand and sing their anthem with increasing loudness and enthusiasm, and the Nazis are completely drowned out. The camera pans across the proud, spirited faces of the French and then focuses on the Nazi's angry reactions, as the senior officer orders Rick's Café closed until 'further notice'. Without need for argument, the latent battle between the French and German sides is exposed in the war between their rousing national anthems.

In the novel *Ben Hur* by Lew Wallace, the character of Messala is a psychologically credible villain who betrays Ben Hur because of their incompatible ideologies. Ben Hur and Messala were boyhood friends who hunted and fished together, and on one occasion Ben Hur even saved Messala's life. All of this changes later when Messala returns home as a Roman tribune and seeks the help of his old friend in keeping the people in line. Ben Hur, however, will not betray them, and Messala confronts him with an ultimatum: 'If you're not for me, then you are against me.' Ben Hur must choose: either to support a friend who cannot respect his contradictory beliefs and who turns against him at the slightest dispute, or to defend his persecuted people. He addresses the unfairness in Messala's question by answering: 'If you put it that way, then I am against you.' In other words, he opposes the choice that his old friend gave, and not the person who gave them. The opposite is true of Messala.

From then on, these once-close friends feud bitterly: when loose tiles from Ben Hur's house fall on a Roman governor, Messala arrests Ben Hur's entire family. After Ben Hur is imprisoned, he escapes, and beats Messala in the infamous chariot race (at which, predictably, Messala cheats by whipping him). The sense of betrayal comes from Ben Hur and Messala's former close friendship, and the fact that he has allowed his beliefs to interfere with that relationship (whereas, we understand that Ben Hur only opposed Messala's opinions). This kind of duplicity, symptomatic of human nature, is often used to great effect as a point of tension in fiction.

Using conflict well requires reader/audience involvement; but conflict does not necessarily imply tragedy or even drama – in fact, our most comic creations can stem from clever rivalry of characters along similar lines. Going back to our ancient Greek dramatists, we can see that they too recognized the comic possibilities springing from man against man. Aristophanes' *Frogs* ridiculed contemporary Greek tragedians, and used some tactics that we can recognize today. Here, the Greek tragedian character of Aeschylus criticizes the style of Euripides' tragedies. They are, he says, so turgid and predictably constructed, that he can ruin them all with 'a little oil flask'. He asks Euripides to recite lines from his plays so he may prove it:

Euripides: Aegyptus, so the widespread rumour runs, with fifty children in a long-oared boat, Landing near Argos . . .
Aeschylus: Lost his little oil flask!
Euripides: It won't be a problem. For to this prologue he won't be able to attach that flask. 'No man exists, who's altogether blest, Either nobly sired he has no livelihood Or else base-born he . . .
Aeschylus: Lost his little oil flask!

Euripides is the stooge to Aeschylus's cruel comedian, always with a smart reply to the unsuspecting straight man. Slapstick comedy, popularized in early silent movies by Buster Keaton, Charlie Chaplin and Laurel and Hardy, comes from these roots and, in a way, both types of conflict stem from the same impulse that simultaneously attracts us towards tragedies. The Greek philosopher Aristotle called this *catharsis*, meaning a kind of purging of one's own pain or grief through watching someone else's.

Conflict within 'pairs' created the most memorable cartoons of the twentieth century; think of Tom and Jerry, Sylvester the cat and Tweetie Pie, Roadrunner and Wiley Coyote, all more recently satirized in *The Simpsons*' Itchy and Scratchy. They employ the same formula: an apparently weaker protagonist,

pursued by stronger antagonist, producing an ongoing battle from which the weaker half wins every time. This simple structure also requires very little characterization because it depends on a familiar battle between natural predators and their prey (cat vs. mouse/bird, coyote vs. roadrunner etc.). Unlike tragedies such as *Romeo and Juliet*, this is not a battle between equals, so we easily grasp the injustice in the smaller/slower/weaker character being eaten/chased/blasted into orbit, and instinctively side with them. Immediately the audience is involved, and ready to tackle the second structural conflict: the weaker character never being sufficiently pathetic or passive to warrant our entire pity, and glee at the antagonist's violent fate. Such comedy is deceptively simple because it continually shifts the reader/audience's position; one minute we feel sorry for Jerry forced to be Tom's sandwich filling and laugh as the cat becomes wallpaper, the next we're pleased that Jerry didn't get away with it entirely.

On-screen chemistry between leading ladies/men is created by an argumentative conflict, often arising from a suppressed desire, usually between intellectual equals, producing the classic 'will-they-won't-they' situation that thrills readers/audiences every time. Whereas in tragic drama, conflict between prospective lovers inevitably ends in death (think *Othello*), comedy lends it a twist, and gives it a happy ending.

Shakespeare's *Much Ado About Nothing* wonderfully illustrates the humour of quick-fire repartee between warring people secretly in love with each other. Keep in mind the tense confrontation between Antigone and Creon at the start of this chapter. In *Much Ado*, Beatrice and Benedick, both acknowledged witty socialites, are forever arguing, and provide entertainment for their friends with their vitriolic disputes. The tension in verbal mud-slinging matches between these two has been memorably reproduced in countless novels, films and sitcoms. See if this reminds you of anything:

Benedick: God keep your ladyship still in that mind! So some gentleman or other shall 'scape a predestinate scratched face.

Beatrice: Scratching could not make it worse, an 'twere such a face as yours were.
Benedick: Well, you are a rare parrot-teacher.
Beatrice: A bird of my tongue is better than a beast of yours.
Benedick: I would my horse had the speed of your tongue, and so good a continuer. But keep your way, i' God's name; I have done.
Beatrice: You always end with a jade's trick: I know you of old.

Within these battles is a conflict between what the characters say, and what they really feel, a subtext that audience/reader are privy to. Conflict like this necessarily requires relief every now and then, for the reader becomes exhausted with high drama without such pauses. These often include moments of tenderness and caring that offer clues to the characters' real feelings, such as Beatrice's final words, 'I know you of old'. Good romantic conflict informs the reader, while keeping the characters in the dark: we watch them play out their frustrations, while knowing that they don't know that they love each other.

The modern equivalents are endless. The hotly contested conflict between *Cheers'* Sam and Rebecca undeniably contributed to its enormous popularity in the 1980s – in fact ratings actually fell when they finally got together. The hit 1980s film *When Harry Met Sally*, which questioned platonic relationships between men and women, saw its main characters at loggerheads for most of the film. Harry and Sally initially hate one another, then sleep together, then hate one another before finally reuniting. At this point in the film (below), Harry and Sally have just met, and are on a long journey to New York. Harry has just declared his theory that women and men cannot be friends, because sex always gets in the way, to which Sally replies that she has many male friends, where there is no sex involved:

Harry: No you don't.
Sally: Yes I do.

Harry: No you don't.
Sally: Yes I do.
Harry: You only think you do.
Sally: Are you saying that I'm having sex with these men without my knowledge?

Harry and Sally's rather stubborn quibbling is incredibly childlike because they use 'yes' and 'no', the ultimate verbal opposites that require no explanation. This reflects their incompatible viewpoints (rather like Antigone and Creon), and refusal to acknowledge the other side's opinions. Again, comedy and tragedy use similar paths exploiting the characters' conflicts in a common goal: the realization that the opponent, an equal, may, in fact, be right – which is something that the audience might need to see, too.

8 Man vs. Himself

> Conscience doth make cowards of us all
> *Hamlet*

Dramatizing a character's inner conflict is an extremely tricky process because gaining reader sympathy is crucial, and if that character doesn't like some aspect of his personality, how on earth are we meant to? Remember the 'good Jerry' and the 'devil Jerry' balanced on either shoulder in the *Tom and Jerry* cartoons? A major character conflict is rooted in being divided between choices of equal weight and value where only one path may be followed.

Conflict and indecision are most effectively associated with Hamlet, who epitomizes the difficulty of being confronted with two choices of equal value. When the ghost of his dead father instructs him to avenge his death by killing his Uncle Claudius (now married to Hamlet's mother), he immediately understands that revenge is the most appropriate action. He is not, however, the man for the job: he prevaricates and philosphizes as to the proper action, always needing more proof of Claudius's guilt, or dreaming up some other reason for not killing the murderer.

While it was necessary for Shakespeare to portray the apparently less admirable aspects of his hero (this being the whole point of the play), it was of equal importance to ensure that the audiences cared about the Dane. Shakespeare used soliloquy to achieve this; when no other character is on stage Hamlet speaks to the audience in several key moments. He considers suicide, his cowardly nature, his nightmares, and these thoughts inform the

audience, helping them to understand his dilemma, and providing an open line to his brain. First he chastizes himself for not acting:

> That I, the son of a dear father murder'd
> Prompted to my revenge by heaven and hell,
> Must like a whore unpack my heart with words
> And fall a-cursing like a very drab,
> A scullion! Fie upon't Foh!

Then, in the line directly after, he changes his tune completely, shifts down a gear, and listens to the thinking Hamlet jumping up and down on his right shoulder:

> About [*concentrates*] my brains. Hmm – I have heard
> That guilty creatures sitting at a play. . . .

And off he goes, planning another way to provide some more conclusive evidence to spur on his revenge. His conflict lies in being intelligent enough to understand both sides of the argument, and therefore unable to follow just the one course.

Another self-imposed conflict rages in Hamlet's feelings of inferiority against Fortinbras, the very model of a vengeful son. Fortinbras, son of Norway, wages wars all throughout Europe during the course of the play, and Hamlet curses his gentle nature, comparing himself unfavourably to Fortinbras's impulsive temperament. Verbalizing his thoughts offers the audience information regarding Fortinbras, Hamlet's feelings about himself ('How stand I then?'), and also allows the audience to add their own thoughts about the fiery Fortinbras and Laertes.

> Rightly to be great
> Is not to stir without great argument,
> But greatly to find quarrel in a straw
> When honour's at the stake.

We may be frustrated with Hamlet for his dithering nature, but respect him for not slaughtering people on whim. So, one of the

ways in which this play engages its audience is to *show* and not have others explain why we should prefer one man to another, and this device also applies to fiction novels.

Edgar Allan Poe's story 'The Tell-Tale Heart' is a vivid example of inner conflict in action. Sporadically addressing himself to his reader, the narrator explains the circumstances of the old man's death, and how he hid his remains under the floorboards of his house. Constantly trying to persuade his reader of his sanity, the narrator's sentences betray his true temperament and state of mental health:

> True! – nervous – very, very dreadfully nervous I had been and am; but why will you say that I am mad? The disease had sharpened my senses – not destroyed – not dulled them. . . . How, then, am I mad? Hearken! and observe how healthily – how calmly I can tell you the whole story.
>
> 'The Tell-Tale Heart'
> *The Works of the Late Edge Allan Poe*, 1850

As you can judge by his quivering tone, the rest of the tale is far from 'calmly' narrated. The number of exclamation and question marks creates a hysterical voice, whose words are in direct conflict with how they are expressed. He is, quite clearly, insane, but is forever finding concrete evidence to affirm his sanity; this includes the sure knowledge that mad people don't think straight, reason, or know how to conceal the truth (as, he boasts, he quite clearly can). But how can the reader understand that he is mad when we have only his testimony to go on? Remember the discussion in Chapter One about how reader expectations are important in interpreting the text? Here he speaks calmly about his next actions:

> The night waned, and I worked hastily, but in silence.

Extracted from any other text, this would seem a reasonable assertion, and one made by a balanced mind. Perhaps, we surmise, he is actually going to give us concrete evidence of his sanity. Read on:

> First of all I dismembered the corpse. I cut off the head and the arms and the legs.

His compulsion to persuade the listener/reader of his sanity indicates an insecurity that manifests itself in the re-emergence of his conscience near the end of the tale. So, when police come to question him, the hacked-up corpse safely stashed underfoot, the killer's own conscience gives him away and shows his guilt. The killer thinks he hears the beating of the old man's heart, the sound growing louder and louder in his mind. The police sitting with him hear nothing, but for the guilty man, the sound of the beating heart increases to the point that he cannot stand it, believing that they have known all along.

> God! – no, no! They heard! – they suspected! – they knew! – they were making a mockery of my horror! – this I thought, and this I think. . . . I could bear those hypocritical smiles no longer! I felt that I must scream or die! and now – again! – hark! louder! louder! louder! louder!

Tormented by the tattoo of heartbeats, and the paranoid belief that they have guessed and are merely pretending not to have heard in order to trap him ('hypocrites' – another conflict between appearance and reality), he confesses on the spot.

The power of the human conscience is what solves the crime in Poe's story. It is the killer's inner conflict that brings him to justice. Poe is able to portray this internal struggle so well because he puts the reader inside the mind of the killer from the very beginning, through establishing a dialogue between narrator and reader (addresser/addressee) which contains a hidden agenda. Without the need for another sane narrator, the reader evinces the truth from the conflict between what the narrator says, and what that information means to us. We judge Hamlet in the same way when he calls himself a coward for not copying Fortinbras or Laertes' rash and bloodthirsty actions. We directly assess the conflict between Hamlet's version of the truth and our own, and see that where Hamlet's indecision may not be ideal

for the role of avenger, it actually reaffirms his stance as a humanitarian and a gentleman.

Consequently, the battle *man vs. himself* also signifies a conflict between his true self, how he believes others see him, and how others actually do see him. As we have seen, Hamlet admired Fortinbras and Laertes for representing the valiant avenger, battling for a 'straw', and appearing courageous.

The battle between the body and self-image is a conflict many millions of people go through every day. Josie, the central character in *Life Size*, by Jenefer Shute, is a woman struggling with anorexia whose need to be in charge of her body spirals dangerously out of control. The first person narrative examines the compulsive behaviour that rules Josie's world so that, as she puts it, 'One day I will be thin enough'. Josie's hatred of flesh and excess matter resonates through her eating habits. Her method is to cut everything in half, then halve it again and again until she reaches a kind of lowest common food denominator. Then she eats. Enacting the same physical reduction on her food as her mind does on her body, Josie battles with herself to attain 'just the bones . . . the pure, clear shape of me'. She obeys her damaging ritual, compelling in its formality, until she is hospitalized, weighing just 67 pounds. There, shown a picture of herself and another anorexic woman, and asked to choose who is thinner, Josie admires the other woman's jutting bones, envious of her thinness. The conflict between appearance and reality has taken its toll, and Josie's mind is at war with her physical self.

For Josie in *Life Size*, the battle to survive – one fought against her mind – is part of her cure: 'Can I learn to be so present? Can I learn to be so full?' To overcome her disabling disease, Josie must relearn how to think, to free herself from the confines of her ritualized eating habits, and to accept herself as she really is.

But inner conflict can have very little to do with how other humans see us; for example, sometimes our conflict with our God, and his religious teachings harrows and confuses. Two novels spring to mind; the first, *The Thorn Birds* by Colleen McCulloch is a much-beloved bestseller, exploring the emotional turmoil resulting from a priest's love for a woman,

and his ambition to follow his spiritual calling. Experiencing a moment of epiphany, Father Ralph realizes that he has been convincing himself against his true feelings, a delusion which is suddenly lifted. The revelation of his need for Meggie comes as a painful shock, and one which will haunt him until he dies.

> He had been wrong. The pain didn't fade. But now loneliness had a name: Meggie, Meggie, Meggie, Meggie. . . .
>
> *The Thorn Birds*

Graham Greene is famous for his brilliant portrayals of characters in spiritual crises; amongst his many novels, *Heart of the Matter* powerfully portrays his character Scobie spiralling into despair, when he embarks on an affair while his wife is overseas. Scobie's reputation for integrity comes under fire when his adultery is exposed, and his propensity for honesty and charity is lost. Above all, he hates the fact that his actions make anyone he loves unhappy, and so, against the teachings of his Catholic faith, he chooses to kill himself. Throughout this spiritual struggle, the two sides argue over whether or not he should kill himself; but, unable to bear his present life, he resolves to end it.

> Now, he thought, I am absolutely alone: this was freezing point.
> But he was wrong. Solitude itself has a voice. It said to him 'Throw away those tablets. You'll never be able to collect enough again. You'll be saved.'

Whatever that voice is, it speaks reason, and the reader agrees with it. For Scobie to die not only goes against his religious teaching, it also subverts the reader's wish for him to stay alive. We experience the conflict of interests, but more importantly, feel the character's agony. And empathizing with characters in fiction is what life is about, too.

9 Man vs. Nature

> I should like flowers very much if I didn't keep on thinking they would all be withered in a few days.
>
> *Jude the Obscure* Thomas Hardy

So far, we have examined the types of conflict that to some extent, man can control, and from which he can occasionally emerge victorious. Whether that might be Hamlet's indecision (he murders Claudius in the end), or winning over one's rival (Messala and Ben Hur). As we have seen, reader empathy is crucial to a successful portrayal of conflict, from which the audience/reader is not isolated. But how does one engage the audience/reader when the central character fights against an invincible force, inexplicable in its injustice?

The nineteenth century Romantic poets revered the forces of Nature: for them, the invincible elements reminded man of his humble beginnings, and undermined his vain attempts to improve himself through scientific exploration. The sense that a greater force existed provided an enduring reminder of both his impotence, and his debt to the world around him, his existence depending upon the goodwill of its omniscient raw power.

In Mary Shelley's *Frankenstein*, Victor Frankenstein's initial experiments as creator of human life dehumanize him. Suffering a nervous breakdown from his obsessive drive to pursue his goal, Frankenstein realizes that his creature is out of control, and it unleashes its devastating power upon his loved ones. For Victor Frankenstein at the beginning of the book, nature is merely a

source for dissection; he digs up bodies in graveyards, and never considers the consequences of his scientific probing. As his creation becomes more and more isolated from his surroundings, the monster, ostracized because of his physical deformities, turns on Victor's family for revenge. After realizing his terrible mistake, Frankenstein simultaneously understands the true power of nature.

> The solemn silence of this glorious presence-chamber of imperial Nature was broken only by the brawling waves. These sublime and magnificent scenes afforded me the greatest consolation that I was capable of receiving ... they elevated me from all littleness of feeling; and although they did not remove my grief, they subdued and tranquillized it. In some degree, also, they diverted my mind from the thoughts over which it had brooded for the last month.

Man underestimating the forces of nature is classically known as hubris. He believes his powers to be indestructible, and therefore needs to meet his nemesis; in other words he has challenged Nature to a duel from which he is highly unlikely to emerge in one piece.

The last and current centuries have seen cinema embrace the very notion of man against nature: *The Poseidon Adventure*, *Jaws*, *Airport*, *Armageddon*, and more recently *Twister* and *Dante's Peak*, are just some of the many films that pit their central characters directly against the elements.

More often than not, the opposing forces, such as tornadoes, volcanoes and the sea cannot be defeated – the central character can only hope to *survive* (not come out victorious such as in *Ben Hur*). So, the formula for many disaster/nature movies involves a plot line that establishes a sympathetic dialogue between audience/reader and protagonist before that character has to face the invincible force.

In *Jaws*, we see that the shark is alive and killing (with the famously menacing fin) before the police lieutenant Martin Brody knows it. When Brody confronts Amity's mayor with this

knowledge, we know he is right and are frustrated when the mayor ignores his warning because of greedy concern for the town's tourist trade:

> VAUGHN (*taking Brody aside*):
> It's all psychological, anyway. You yell 'Barracuda' and everyone says 'huh'. You yell 'Shark' and we've got a panic on our hands. I think we all agree we don't need a panic this close to the Fourth of July.

The audience, equipped with the evidence of the killer shark's existence, automatically oppose the mayor, and, so, when Jaws returns for a new killing, the audience's empathy for the lieutenant is firmly established. *Dante's Peak* follows a similar plotline, as the professor encounters hostility when warning the town of Dante's Peak of the dormant volcano. His survival (as opposed to Brody's glorious destruction of Jaws) is just as courageous, simply because of the odds of survival, and of the previous barriers he had to face.

Survival rather than all-out victory, therefore, is the aim of the conflicting sides in countless sci-fi films. Here, the absence of parity presents a David and Goliath scenario; the antagonists are much bigger, much stronger, far more technologically advanced, and possess no concept of mercy. In this way, conflict in science fiction and disaster movies has done for twenty-first century national identity what propagandist war movies did in the 1940s: they unite mankind against a common aggressor.

Independence Day (1998) – and its huge box office success – is a good illustration of how a conflict can empower an audience. Set in present-day America, the nation is set to greet another Fourth of July with a new battle: not of independence from the British, but from a seemingly invincible armada of sinister spaceships, intent on bringing Earth to its knees. US family-man President (Bill Pullman) enlists the heroes, played by Will Smith and Jeff Goldblum, to 'whoop ET's butt', after the spacecrafts decimate major cities worldwide. Again, the central characters pull together against the ubiquitous foe to assert their

national identity, and, in turn, the protagonists represent a gamut of ethnic, sexual, and regional identities. So instead of asserting its racial independence from other countries, this Independence Day finds America's polyglot community united.

Together, the all-American heroes are not matched by evil foils but faceless predators amassed in incredible numbers. This intensifies the David and Goliath set up: instead of an equivalent head to head(s) battle, Will Smith and the aliens are apparently disproportionately matched. Any victory is therefore a bonus, especially one which plays on the David and Goliath story (David hitting Goliath's weak spot), and on the fact that the US pilots are the only people daring and skilful enough to battle against the aliens, and also where the resolution implies a worldwide independence day.

Ancient Greek dramatists understood the unifying potential of representing their nation under attack from a common aggressor. In fact, the word barbarian comes from the Greek *barbaros*, meaning 'he who doesn't speak Greek.' For ancient Greeks, foreignness was originally a linguistic construct. This word was first used in Greek plays such as *Medea*, and *The Persae*, which depicted foreigners as uncivilized murderers, and incestuous child-eaters, and were written during the Peloponnesian wars (internal Ancient Greek skirmishes). Greek dramatists hoped to sway public support away from these battles, deemed harmful to the nation's identity and international standing, by showing how well the nation could pull together in times of war, especially against those nations less cultured, and therefore with more excuse for warmongering, than the Greeks. A recent example might be in films dating from the 1950s, and also the James Bond films set during the Cold War, demonizing the KGB, and setting our good British hero against brutally large Russian spies and betrayers.

Another way we might think about man's struggle with elements beyond his control, is to substitute the notion of Fate for the idea of Nature. Countless books, plays and films have studied the influence that Fate has on our lives: some argue that Fate is merely a logical human attempt to rationalize his chaotic

world; others protest that their own lives have been shaped by a force that clearly predestined them to be in a certain place at a certain time.

Thomas Hardy was a great believer in the power of Fate, how it controlled our lives, and how we must, in turn, respect its indomitable authority. Hardy's work suggests that the human condition may only attempt to make the best of its fate; the unavoidable is just that, and Fate resolves matters whether we like it or note. The reader's involvement depends on our sympathy with the characters, and, how, even though their foolish actions may have encouraged the terrible consequences, they really did not deserve such treatment.

In Hardy's novel *Far From the Madding Crowd* the central character Bathsheba Everdine disobeys the author's golden rule and makes a frivolous decision (to whom she will send a Valentine's card) by throwing a bible in the air and seeing which way up it lands. Fate lends its own hand, and Bathseba's choice – either a handsome village boy, or moral backbone Farmer Boldwood – has tragic consequences. Believing Bathsheba to be in love with him after receiving her card, Boldwood pursues her, developing an intense obsession which culminates in his eventual suicide.

Hardy's poem 'The Convergence of the Twain' was written after the sinking of the *Titanic* in 1912. As we all know from the hit 1999 film (and countless previous productions) prior to its destruction, the *Titanic* was touted as the unsinkable ship. In other words, man declared himself ruler of the elements (the sea), dismissing the power of nature. In the poem, Hardy describes how both the ship, symbolizing man's hubris, and the iceberg (Nature) were created simultaneously, and that the iceberg, similar in its enormity and stature would become HMS Titanic's nemesis:

VI
Well: while was fashioning
This creature of cleaving wing,
The Immanent Will that stirs and urges everything

VII
Prepared a sinister mate
For her – so gaily great –
A Shape of Ice, for the time far and dissociate.

VIII
And as the smart ship grew
In stature, grace and hue,
In shadowy silent distance grew the Iceberg too.

Hardy refers to Fate/God as the 'Immanent Will', the consummation of the mating being in the *Titanic*'s destruction. The price of human vanity is its ultimate dissolution, and the story of the *Titanic* depicts the tragic struggles of man to harness nature for his own ends. The conflict of man against nature, therefore, cannot involve the kind of victorious resolution of both the conflicts of man against man and man against himself. It is really a triumph of the human spirit against Fate, or any other element he cannot hope to conquer, and the respectful understanding of power within its own limitations.

PART III
SETTING

10 Establishing Your Setting

Some fiction writers say that setting is their favourite element in creating new words. When they cannot come up with a character, a situation of conflict or a plot they like, they start with a setting that fascinates them. They have learned that setting, at least for them, is a springboard into their stories.

Setting is the surroundings or environment of the story. Some stories dictate the setting. Could *Gone with the Wind* have taken place anywhere other than the South? If you know your story line, or plot before you begin to write, then your setting will be set and clear in your mind. If the villain in *Day of the Jackal* is trying to assassinate Charles de Gaulle, the President of France, then much of the story will obviously take place with him on the way to Paris. In truth, Frederick Forsyth's novel builds to a powerful suspense as the villain draws closer and closer to Paris.

How Green Was My Valley takes place in the coal mining area of Wales, a setting which was crucial to the story. The hard life of coal-mining is part and parcel of the conflict in this story. Some of the key family's sons are forced to leave home because they see no future for themselves if they stay but working in the mines. Most of *Ben Hur* is set in Judea or in Rome, though there are some scenes at sea.

North by Northwest had events going on in New York, Chicago, and Rapid City, South Dakota. The story line of *I, Claudius*, dealing with the emperors as it did, took place mostly in Rome, as you would expect.

Sometimes the setting is not so obvious. The time traveller in

The Time Machine is seeking an ideal civilization and eventually goes far into the future – to the year 802,701. His home in Richmond is the opening setting, and it is the weekly Thursday-night dinner party when three close friends are accustomed to the presence of their host. The story opens with the arrival of the time traveller in a terrible condition.

Wells uses three settings – the traveller's home, the first test runs of the machine, and the world of the Eloi and Morlocks. This novel was the first real classic of science fiction. Did Wells think of the setting first? He clearly had to have the traveller choose the future over the past. Wells was curious what lay in store for the human race and whether mankind would learn to live in peace. I believe it was a much finer novel because the focus Wells went with was a deep future setting rather than the past.

Wells describes the world of 802,701 well: 'As the hail cleared and a blue summer sky appeared, I began to see other vast shapes – huge buildings with tall columns.

When planning your setting it will help if you think about three connections with it:

- the geographical location
- the physical location
- the historical location.

Once Charles Dickens knew he wanted the background setting of the French Revolution, he had the historical, geographical, and physical locations of Paris and London for *A Tale of Two Cities*.

The theatre had a profound influence on Dickens. He spent almost every single night there for a period of three years. He was more a dramatist than novelist. This affected his style, technique, and choice of settings which are those of the theatre.

There are no rules about setting. You can choose to say a little about it or a lot. Many story writers limit their setting descriptions to achieve compression as this is the challenge of the short story. A novel is another matter. A novelist has unlimited scope

and may spend a hundred or more pages on the setting, delving into its historical and physical significance.

You also need to be alert to the fact that even a simple setting can trigger something, a seed, a spark, a question that leads you to an idea, a fictional work. Anthony Trollope once took an evening stroll in the area around Salisbury Cathedral while he was working in the area as a postal inspector. That evening stroll led to his Barsetshire novels.

This shows that you would do well to consider your travels, both past and future, as possible springboards to new fiction. There is something very stimulating about travel for a fiction writer. New sights, cities, scenes, landscapes, climates and people may have intriguing and rewarding influences on your future works. I have yet to meet a writer who does not love travel and the observations and reactions it produces.

My own travels all over England, for example, have brought a variety of setting ideas and have led me to new fiction and nonfiction works. When a relative once asked me why I had made so many trips to London – and asked if I grew tired of the same place – I replied with one of the best quotes from Samuel Johnson: 'When a man is tired of London, he is tired of life.'

11 Setting in Different Times

In its most simple form, setting is a blank canvas upon which we build up various shades of character and mood, structures and shapes. Think of how different types of fiction conjure setting, and you could be dealing with anything from the direct simplicity of *James Bond*:

> 0800. Military HQ Afghanistan

to the kind of detailed description of place that Dickens used so effectively in *Bleak House*.

A brief look at twentieth-century cinema reveals the kinds of settings that were in vogue during different time periods; for example in the 1960s, the epic *Cleopatra* set in motion a whole array of Roman films depicting the values and structure of the Empire. *Quo Vadis* is an excellent example of the battle between the Christians and lions, asserting and redefining the religion not just for the fictional characters, but also the cinemagoers, perhaps disillusioned with the events of the day. Rome, as shown in *Ben Hur*, and countless other works, represented the indissoluble values of pride, courage and selflessness for the glory of the powerful Empire.

Swashbuckling films of the 1930s and 1940s asserted a brave hero, who would partake of derring-do and fight evil at any cost. Whereas we might not go in for such clichéd films nowadays, science fiction has taken over where Errol Flynn et al. left off, making the reassertion of good over evil a universal theme.

SETTING IN DIFFERENT TIMES

When you're setting fiction in the past, remember – it is a completely different kettle of fish from the invented universe of, say, Frodo Baggins, or Harry Potter. For when a reader already knows 'facts' about the period that he is about to enter, the writer must find some way of keeping his attention, as well as giving him what he expects to read/see.

So, if you're intending to set a novel in a certain place, then, unless you're Shakespeare, making it up off the top of your head won't be nearly as effective as good, thorough research (more about that later). The groundlings who saw the bard's play first, would probably never have got to travel to Verona, or Rome, or Padua – even if they did, then they would not have been exposed to the societies at work in Shakespeare's comedies and tragedies.

As ever, there's some theory that goes with this; think back to the chapter on 'Beginnings', and how a reader interacts with the text by continually having his expectations modified or confirmed. Well, imagine if you will those eighteenth-century duellists Count LeFèvre and Lord Hamilton fighting over Lady Windermere against the richly textured backdrop of Blaine Castle, their figures darting in and out of the pylons. This example may seem a little extreme, but such anachronisms modify the reader's expectations in a completely unintentional way. If yours is historical fiction, then credit your reader with some sense, and surprise him with a well-placed twist in the plot, and not the art deco clock on Friar Bedwede's medieval mantelpiece.

What are the reasons for setting a novel in different historical periods? Perhaps nineteenth-century France might capture your imagination, or sixteenth-century England could fire your furnace. Probably one of the best ways to start understanding a historical period is to read the literature of the time. Fans of historical romance nowadays get the best of both worlds following the dissolution of censorship, but remember, though your novel is not under the same restrictions as Jane Austen, it is constrained by different boundaries. You don't want your readers thinking, *No, she would never have done that*, and in this way, historical realism penetrates into every crevice of your fiction.

History can be used to draw parallels with the present day; in fact, all of Shakespeare's plays came from other historical sources, which he adapted in order to create those famous tragedies that we know today. History, circular in its nature, is an enduring source of material for parallels with the present day; you might think of many others, but one such example is Arthur Miller's *The Crucible*, which explored seventeenth-century witch hunts to highlight the injustice of the McCarthy era, and the relentless investigation into suspected communists.

Along with anachronistic problems comes the additional baggage of *values*. By values, I mean anything ranging from morality to social restrictions. For example, you wouldn't have an eighteenth-century girl shouting across the street to the bloke she fancies, although this would be completely acceptable in a *Bridget Jones*-esque novel in the twenty-first century. In the very first instance, then, historical fiction must be well researched.

So, placing your characters in history achieves three things:

- Situates reader in a time he probably knows about
- Provides an opportunity to comment on historical events
- Simultaneously allows for critical parallels with the present day.

George Eliot set her novel *Middlemarch* in the near past, in order to highlight the backward philosophy of the reactionary inhabitants of her fictional town. Wary of new medicinal techniques, and protesting vehemently against the onset of the railroad, the Middlemarchers form a consistent barrier against the progressive attitude of the two main characters, Dorothea and Lydgate. Every so often, these central players are put in the perspective of the past, and are framed by the events that surround them:

> When George IV was still king. When the Duke of Wellington was Prime Minister, and Mr Vincy was Mayor of the old corporation in Middlemarch, Mrs Casaubon, born Dorothea Brooke, had taken her wedding journey to Rome.

SETTING IN DIFFERENT TIMES

The enormous room on the ground floor faced towards the north. Cold for all the summer beyond the panes, for all the tropical heat of the room itself, a harsh thin light glared through the windows, hungrily seeking some draped lay figure. . . .

As the annals of history echo in our present, so a bleak, forbidding future lies ahead. Many of the scientific improvements which surround us today have been predicted in fiction of many years ago; who knows what you can write in the fiction of tomorrow?

12 Atmosphere and Setting

It was a bright cold day in April, and the clocks were striking thirteen. Winston Smith, his chin nuzzled into his breast in an effort to escape the vile wind, slipped quickly through the glass doors of Victory Mansions, though not quickly enough to prevent a swirl of gritty dust from entering along with him.

<div align="right">George Orwell, <i>1984</i></div>

He saw ... a long valley floored with green pasturage on which a herd of deer browsed. Perfect live oaks grew in the meadow of the lovely place, and the hills hugged it jealously against the fog and the wind.

<div align="right">John Steinbeck, <i>The Pastures of Heaven</i></div>

Whether your fictive world is a long time ago, in a galaxy far, far away, or way beyond our dreams in the future, it needs in some way to be grounded in the reality of today. This reality is necessary for the reader to be able to interpret and therefore interact with the values on offer. From one extreme to another, a completely fictional world might appear to be wholly at the writer's whim, but this is illusory. Fictional worlds are subject to similar kinds of restrictions as their historical counterparts, and both worlds have values that the reader and author share.

In the above quotations, we saw two very different settings, using the sense of place in alternative ways. The word *juxtaposition* is literary talk for using something positioned in contrast with something else to make a point, or create an interesting sense of

mood. For instance, films like to put couples kissing in the rain. Visually, this is rather sensuous (beautiful people, dripping wet), and examples include *Breakfast at Tiffany's* and *Four Weddings and a Funeral*. Water is also symbolically associated with our emotions; visually it reminds us of tears (what would happen if everything goes wrong), and the idea of rain as miserable, hateful weather contrasts with the warm glow of happy love. And that's just the weather! Think how a *place* can alter a scene immeasurably.

The 1950s saw a renaissance of Roman films, from *Cleopatra* to *The Robe, Ben Hur* and countless others. When you write about Rome, you can't just include a load of pillars and people in togas with leaves round their heads, and upside down brooms on their helmets. A predominantly male society, Rome of its day stressed public duty over private whims, and saw its ideal in pragmatic, militarian terms. If you want to place your text in that time, you too, must adhere to its norms.

Shakespeare sourced all his Roman stories from historical commentators, and one of his most famous is the enduring love story *Antony and Cleopatra*. This play is important for two reasons; firstly, that *Cleopatra* remains one of the most popular and lavish movies of the last century; secondly, that Rome and Cleopatra's Alexandria contrasted to explore the dichotomy of values of the day (extremely relevant for the 1950/60s). Conversely, the fact that at no point in Shakespeare's original *Antony and Cleopatra* is there a scene change, meant that in Shakespeare's Globe theatre, the only indication of where the characters were, came from the costume, the actors, and Shakespeare's beautiful word painting. As well as her sumptuous surroundings, the imagery connected with Cleopatra still conjures up the idea of delicious excess.

> Other women cloy
> The appetites they feed, but she makes hungry
> Where she most satiates.

The contrast of Antony and Cleopatra, Rome and Egypt, can be explored through opposites: the masculine coldness of Rome

against the feminine bounty of Alexandria; emotions vs. sterility. But it is the characters themselves who really bring Rome and Egypt into conflict.

Wuthering Heights is the most well-worn example of a setting mirroring the flaming passions of the central characters, Cathy and Heathcliffe. The novel is a passionate exploration of how Heathcliffe's jealousy destroys all close to him. The dark, wild moors of Yorkshire are an important parallel to Heathcliffe; here, the narrator describes his first impressions of the moors:

> On that bleak hill-top the earth was hard with a black frost and the air made me shiver through every limb.

Everyone in the household is trying to be calm, suppressing Heathcliffe's gypsy blood, and Cathy denying her love for her adopted brother. Outside, the wildness continually taunts them by doing whatever it wants, whenever it feels like it. The moors represent what Cathy and Heathcliffe would be if they were not made to control their actions and emotions. If you use setting in this way, it's extremely important to assume that your reader is half-full, and not half-empty, and ready to interpret at will. Here, Catherine's future husband Edgar enters the room as Heathcliffe leaves:

> Doubtless Catherine marked the difference between her friends as one came in and the other went out. The contrast resembled what you see in exchanging a bleak, hilly, coal country for a beautiful fertile valley, and his voice and greeting were as opposite as his aspect.

In other words, when I read *Wuthering Heights* I was aware of the tension between the central characters, and also I visualized the tempestuous moorland when Brontë described it. Between these two points (controlled love, tempestuous lands) there is a gap. In this gap, I inserted my conclusion. So, juxtaposition is at its most effective when you leave maybe a third of the work for the reader to do.

ATMOSPHERE AND SETTING

Think *Blade Runner*, and the post-modern future is plunged into darkness, plagued by torrential rain, and is penned in by an oppressive atmosphere. Humans have worn out their present world and have built a new, improved one, known as the Offworld colonies. The bright 'Other' represents the new hope for the future, and the people salute the good old days, via the use of pastiche where everything is simply a repetition of what came before.

Countless science fiction films display hours of technical wizardry and imaginative planning, but their essence remains at heart very similar to that of historical or contemporary fiction. Based around our three basic plots, there are characters with whom we either sympathize or detest, and they deal with the universal themes of good/evil, right/wrong, love/hate. Plot points aside, the values your setting offers are the portals through which your reader will enter, bearing in mind they may be completely alienated by otherwise unfamiliar territory.

J.R.R. Tolkien's magnificent *The Hobbit* and *The Lord of the Rings* trilogy created an entire world, based loosely around our own folklore. Tolkien invited adults and children alike to share in Middle Earth – but how did he achieve such a universal transformation of his fictional world? He used narrative techniques very similar to eighteenth and nineteenth-century novels, including the omniscient narrator. During a tense scene in *The Hobbit*, the hero Bilbo Baggins stumbles across some trolls, and hears a noise in the forest:

> I don't suppose you or I would have noticed anything at all on a windy night, not if the whole cavalcade had passed two feet off.

So, although the main character is alien to us, at least the narrator is ready to comment; he explains what we don't know, he understands human limitations, and is on our side.

We've reached an important point; such fantasy worlds often use a plot line which originates from myths and fairy tales: the hero quest. *The Hobbit* is like this too; a hobbit, comfortable in

his humdrum existence, is hurled into an exciting adventure looking for stolen gold. In other words, a stranger to the fantasy world enters it at the same point as the reader, and therefore provides a useful point of contact through which the author can inform the reader. *Star Wars, Dan Dare, Flash Gordon, The Never Ending Story* trilogy, *Alice in Wonderland* and Dante's *The Divine Comedy* are just some of the thousands of works that use such a simple method of uniting the reader and central character as soon as the book begins. J.K. Rowling's *Harry Potter* series illustrates how a completely original idea can seem so convincing to the millions of readers who are touched by the young boy and his friends, as they progress through Hogwarts' School of Witches and Wizards. In a world divided between a magical community and Muggles (ordinary people) living side by side, orphan Harry Potter lives neglected by his aunt and uncle until he discovers that he is a wizard. Amongst the many ways in which J.K. Rowling brings her story to life, is the parallel between the magical community and our Muggle world; for example, broomsticks range from the lower brand Cleansweeps to the top of the range Firebolts (showing society's different strata). The bonds that hold families together are the same, and love remains a universal power binding together all that is good.

Mythology, legend, fairy tales, and the fiction of today all have one thing in common; they are all about people communicating with one another, bridging the divide between different times and cultures. The atmosphere you evoke in your fictional world must create interesting contrasts, or parallels with the theme of the book: get it wrong, and you can ruin the whole mood of a scene; get it right, and you will have created the kind of emotional response that stays with the reader for a very long time.

PART IV
DIALOGUE

13 Know the Period You Are Writing About

When the author of *Nicholas and Alexandra* began work on the novel, he knew that it was imperative that he first saturate himself with the time period he would be writing about, the era he had chosen, which led up to the murder of the czar and his family.

When a fiction writer chooses a certain time period, there is an implied responsibility to pay your dues first by learning as much about that period of history as possible. This can be done in a number of ways, and we will start with one of the most exciting new research methods – the Internet.

If you need to know whether a certain night in Paris in 1875 was cold, rainy, clear, or whatever, the Internet can no doubt provide the information. The Internet has opened up a whole new world of research for writers, and with a few clicks a writer can now tap into earlier time periods, find out what was going on, the key events of the day, and obtain print-outs, if desired, of detailed information. The long treks to the library that former writers made will no doubt be cut in half and, although library research will still take place, the Internet now makes a lot of it faster, easier, and more direct.

Consider these opportunities presented by the Internet:

- No medium has ever sprung up so quickly and captured the public's imagination like the Internet. It's a fantastic business opportunity for writers of all ages.

- The newspapers and magazines of the world (increasingly) are available to a writer via the Internet. So are all kinds of news summaries, editorials, and analysis.
- The Internet is the world's largest sales and marketing tool. It can help writers advertise and sell their books and writing. The simple reason writers are not using the Internet more is that many writers (and authors) are not good at marketing. The fact remains that the Internet is a great way for writers to increase their number of sales.
- As a research tool, the Internet is unparalleled in modern history. Think of it if you prefer as a huge treasure trove of fact, news, analysis, a source of new ideas, a way to get numbers and figures into your hands fast, and an ideal way to obtain information on almost every subject imaginable.
- Some authors are choosing to have their own personal Web site. Once it is set up, they use it to promote their book titles or their latest work. They also use it to let publishers read excerpts from their book in progress and then get back to them on it. This reaction can then be used to interest publishers. This is exactly what author James Halperin did with his first book entitled *The Truth Machine*.
- A writer can collect e-mail addresses of potential customers and friends or associates. Then the writer can send them brief messages from time to time and tell them how the latest work, book or story, is selling, how it is being received. Over a period of time these contacts can help a writer market the book.
- A search engine is a service location on the Internet. Huge amounts of information are catalogued here, including all kinds of reference material, product information, user names, and Web site addresses. These search engines use robot devices that browse the Web 24 hours a day to gather information. This clearly makes it a lot easier for writers to find what they need.
- All writers can make better and more consistent use of the Internet, which is here to stay. As Internet consultant Charles Austin puts it, 'Embrace the Web, for it's like an express train. You can either jump onboard or it will run you down.'

KNOW THE PERIOD YOU ARE WRITING ABOUT

Selected books help spotlight an era and when I was writing my Second World War novel, one book I spent a lot of time with was *The Diary of Anne Frank*. It gave me a feel for the desperate atmosphere of that era when innocent human beings were being cut off from loved ones, locked up, transported to death camps, and systematically murdered. In spite of the terrors, young Anne Frank was still able to write in her diary that she 'still believed that most people are basically good at heart'.

What was extra helpful about her diary was the fact you can skip around in it and read her various entries for different dates during the two years Anne and her family hid from the Nazis only finally to be captured and sent to death camps, where Anne, her sister, and mother died. Only her father survived and later got his daughter's diary published, immortalizing Anne's name and spirit for all time.

Whatever time period or era a writer wishes to describe there are special books that can help give you a feeling of those times, what was going on, perhaps major events, how people thought, the clothes they wore, what made them happy or sad, and many more details.

The same is true for magazines some of which date way back and can provide information and a feeling for the times. There is one called *Women's Wear Daily*, that tells how people dressed in the early part of the last century.

There are literally thousands of magazines out there and also journals, newsletters, company publications, social booklets, brochures, and more. Some magazines, for example, specialize in the American Civil War era and would be of great help to a writer interested in those years.

Every writer should also keep in mind that large university libraries often have a large selection of magazines to choose from and examine. Do not limit yourself to city libraries or those in your town or community. My first visit to the Library of Congress, in Washington, was overwhelming. The same is true for the New York Public Library, which has many fine research resources.

I have also spent many happy hours in The British Museum

and also in superb libraries all over Britain. Canadian libraries in Toronto, Vancouver, and Montreal offer a wide array of books and research tools.

I hope to spend an entire summer or year travelling throughout Britain, though I have already been there twenty times since the mid-1980s and am convinced, if I did live before, one or more lifetimes I enjoyed in England.

Travel in itself opens up a huge total variety of research locations, and one can easily become so fascinated with research, itself, that you never actually start a fictional work. So consider yourself warned.

Back in Tennessee years ago, I once worked on a story set in the time of Andrew Jackson. I found lots of information in the Nashville area, where his home was, and spent the better part of several days going all over his home, The Hermitage, some twelve miles from the city.

The walking tour of The Hermitage began at the carriage-house. I saw the grounds, outdoor buildings, and beautiful home of the general and president. The rooms, plan and furniture in the home are authentic, and costumed hostesses told tour groups about The Hermitage and answered questions.

A sign at the carriage-house proclaimed the fact that it took 'Old Hickory' 30 days to go by carriage from Nashville to Washington, D.C., which proved to be a bit of helpful information in learning that travel, in Jackson's era, took much longer.

Many writers overlook one research source and that is the notes they took during school or college history classes. If you did take notes, and many students filled up various notebooks with information, it could be useful in adding to your understanding of a previous era.

In truth, I used some of my World War II history class notes while writing that novel.

Looking through a number of new and older history books can be useful for getting certain dates and discovering when certain events took place.

I believe that old diaries can be goldmines of research for writers. They are sometimes difficult to find but very useful.

KNOW THE PERIOD YOU ARE WRITING ABOUT

One clear example is a non-fiction book that gave me a good understanding of the 1940s. This book was the correspondence between the genius editor, Max Perkins, and Hemingway, Scott Fitzgerald, and Thomas Wolfe, providing real insight into that era and also the publishing industry of those years.

The diaries of famous generals help show what the world at war was like. General George S. Patton's diary, for example, was useful.

When writing an American Civil War story, I requested some photos (then free) from the Department of the Interior. They sent me quite a few photos of Civil War battlefields, and looking them over was helpful.

Writers often overlook photo sources, but there are still some free ones out there ... though not as many as earlier. Photo agencies all charge various fees, but historical societies often charge low fees for excellent pictures.

Over the years a writer will discover that photo files seem to grow. I had no idea when I moved a year ago, and came across them, that I had so many files of photos.

Letters and correspondence between notables of an era can be very useful to a writer. One good example of this is the letters exchanged between John Adams and Thomas Jefferson. They had been more or less enemies in earlier years, but Adams mellowed as he grew older, and the two former presidents became good friends via their correspondence. They both even died the same day with John Adams passing first and saying, as his last words, 'Thomas Jefferson still lives'.

Of all the above resources, I believe that personal visits to the actual locations can often prove to be the most helpful to a writer. The reason is you are there in person and that helps to get a feel for what happened. In Canterbury, I actually stood at the exact spot in the beautiful cathedral, where Thomas Becket was murdered. There is a special marker there, and I could visualize the king's guards coming in from the side door early that morning while Becket was at the altar praying.

I once worked on a story set in 1850 Paris and found books and articles about the impressive people of that era to be most

helpful. These were books and information about Chopin, George Sand, Victor Hugo, Dumas, and others. Reading about the contemporaries of a given era adds to your overall knowledge of the time.

Every country has its own list of special sources for information and research. I can personally say that the Government Printing Office in Washington in America has been very helpful over the years. A writer (or anyone else for that matter) can simply write to them and request that your name be added to their list. Then you will receive a list from time to time of the new printed information (books, booklets, magazines, and shorter materials) the government has published. This can be very helpful for any writer. There is a charge now for most of the new materials offered, but simply seeing what is available can be useful. A writer can then order any of the books or booklets listed.

In writing my World War II novel, I think what would have helped me more than anything would have been a personal trip to Germany, to Berlin. I'm sure the libraries there would have proven useful, but simply visiting the city of Berlin, walking around, and talking to some of the older people there, who lived through that era would have been extremely helpful.

Whenever you can get interviews with people who were actually on the scene, or authorities on the subject, can be the best research sources of all.

Whatever historical period you choose to write about, I urge you to pick one that truly appeals to you. You will be spending a lot of time learning about it, and in a sense going back there mentally, so it is naturally much better if that era is of real interest to you.

Perhaps some of the following historical events and periods might get you interested or thinking along these lines. Good luck and happy research to you:

- The Alamo
- The London Blitz
- The American Civil War

KNOW THE PERIOD YOU ARE WRITING ABOUT

- The First or Second World War
- The Norman Conquest
- Man's arrival on the Moon
- Invention of the telephone
- Invasion of Poland
- The English civil war
- Discovery of gold in California
- Unleashing of the atomic bomb
- Discovery of penicillin
- The influenza epidemic of 1918
- Launching of the first successful rocket
- Arrival of the Vikings
- The invention of the motor car
- The first cloning of an animal

14 Realistic Dialogue

Most authorities, including successful authors, agree that as much as half of your work can be dialogue. However, as John Braine, successful author of *Room at the Top*, says, 'As a working rule, not more than one half of any novel should be dialogue.'

Dialogue is what the characters of a fictional work are saying to each other. Characters obviously live and move within the pages of your fiction, so that means they carry on conversations, and interact with others.

If the characters are real, and they must seem that way to the reader, then they talk like you and me. When you talk to a friend, relative, or neighbour, for example, you do not finish every sentence. You speak in phrases and fragments. If you doubt this, notice the speech patterns of other people. People also rarely make long statements.

Charles Dickens once told a friend that every word said by his characters was distinctly heard by him. Dickens was in truth more of a dramatist, and his settings and plots are theatrical. His characters seem to be playing parts. While he was writing he would sometimes jump up and rush to a mirror to see the reflection of the facial expression of his characters.

The point is that how your characters speak, the way in which they communicate, must ring true to life. In real life people say surprising and even stupid things at times. Once again let us look at the classic *Gone with the Wind*. At the door, when Rhett Butler is leaving Scarlett at the end of the story, she asks him:

'Where will I go, what shall I do?' His response is precise: 'Frankly, my dear, I don't give a damn!'

What Rhett Butler said was predictable by that time, but the question Scarlett asked was strange when you consider her long obsession with Ashley Wilkes. Perhaps, finally, Scarlett was beginning to come to her senses and to realize how much she loved Rhett, but it was too late at that point.

Then, in the last spoken lines of the story, Scarlett talks to herself. 'I'll go back to Tara, and I'll find some way to get him back. After all, tomorrow is another day.' Put yourself in her place. Her husband has walked out on her completely disgusted. Is it not human at that point to talk to herself? Many women in her place would probably do so.

What if Margaret Mitchell had simply ended her novel with Rhett Butler's remark and Scarlett slamming the door? Readers would have felt cheated because they knew even earlier in the story that Rhett is leaving her. They look forward to seeing Scarlett get what she deserves after flaunting her obsession for Ashley before Rhett for so long. You can almost hear them saying to themselves, 'Oh, boy, now Scarlett has lost Rhett. It's her own fault.' They wanted to see her reaction. Margaret Mitchell knew Scarlett well by then and showed her typical reaction of first tears, then despair, then the realization of how much strength she got from Tara. Then wham, the idea hit Scarlett. Why not go home, back to Tara? Tara was a symbol of hope for her. At Tara she could sort it all out and figure out a way to get Rhett back. It is the right ending for Scarlett and the right ending for the novel.

Once a writer knows what kind of novel or short story he or she is writing, clues will come regarding the dialogue. In *From the Terrace*, for example, author John O'Hara knew that Alfred Eaton's marriage to Mary St John would be a disaster. Once he knew that, the nature of the dialogue was clear. Alfred and his wife would fight a lot, so the dialogue in those scenes would be argumentative.

In one of my early short stories, a truck driver remembers a separation from his wife that led to an amicable divorce. Ross

and his wife had wished each other good luck and gone their separate ways.

Ross is driving along the highway and thinking about this, and I decided that he needed to talk to himself a bit so he sums it all up this way: 'Oh, well that's all five years in the past. Wherever you are, Marie, I wish you the best.'

Two days later he is having lunch when Marie sits down in the booth across from him and says hello. The dialogue at that point almost dictated itself. I knew it would be friendly, and that they would want to catch up on each other's lives. Here is how their conversation in the restaurant evolved:

'Hello, Ross.'

He nearly choked on a bite of apple and crust when he looked at her. 'Marie, what are you doing here? How are you?' He dropped his fork and offered his hand.

She laughed. 'I'm fine. I'm here for the same reason you are.'

'How long has it been?

'Since we've seen each other? December of five years ago.'

'Did you stay in Indiana?'

'I was in Indianapolis most of the time.'

'Then what?'

'I moved to South Bend.'

He paused. 'Isn't that the town where the fireplugs were turned into soldiers?'

'Awhile back, you still have a good memory.'

'For some things, I guess.'

'Are you still in Chicago?' she asked.

He ignored the question. 'I wrote you, but my letters came back.'

'I was never good about answering letters. Like they say, Ross, when it's over it's over.'

'It's never been over for me.' He put his hand on hers. 'I've missed you, Marie. Did you marry again?'

She moved her hand away. 'No, did you?'

He shook his head. 'No way.'

REALISTIC DIALOGUE

There are two basic ways you can go with dialogue. You can determine in advance that no more than half of your novel will be dialogue, perhaps just nearing that point, or you can let the narrative itself guide you. If a scene calls for it, use dialogue.

Some fiction writers do a lot of planning ahead of time. Others prefer to just write and let the dialogue evolve where it will and how much of it. As long as you are certain that no more than half of your novel is dialogue, you should be fine.

15 Listen to Your Characters

There is a magical quality in fiction. This quality is that once you know your characters well and have brought them to life, you will be amazed how they whisper in your ear at times and tell you what they want to do.

Is this hocus pocus? No. It seems to be one of the rewards for the hard work an author puts in. The research, planning, character sketches, visual images, writing, rewriting and generally living with the characters, pays off handsomely at times. Author Ray Bradbury confirms that it has happened at times; some of his characters have whispered to him what they want to do in his stories.

But this magic will never happen for you unless you get to know your characters so well that you can see them in your mind's eye, hear their conversations and know their thoughts and motivations. Once you reach that point, you will instinctively know what they should say to each other. The dialogue will then write itself. You will only have to listen to what your characters say.

Incredible as it may sound, there are authors who on occasion have felt like mere onlookers watching their stories unfold. The characters have taken over at this point and have said and done what they wished. It happens rarely, but when it does you will marvel at the strangeness and power of it.

Author Jack Bickham offered a helpful suggestion in his book *Writing Novels That Sell*: 'Simplify your dialogue transactions. Send one tennis ball over the net at a time. If a character wants

LISTEN TO YOUR CHARACTERS

to ask what time it is, mention that it's a nice day, and say he is leaving at midnight for London, you must break up this information.' In other words, he must first ask what time it is. After he gets an answer, let him remark that it is a nice day and get a response. Then finally, let him say he is leaving for London and get an answer.

Whenever you read a novel or short story, pay attention to the dialogue. Ask yourself the following questions:

- Is the dialogue presented the way real people talk?
- Is it mostly short comments?
- Do the characters talk in the manner of the country or region they come from?
- How are foreign accents indicated? Is it made clear to the reader via their speech pattern that they sound different?
- Does one character sometimes interrupt another?
- Are there too many 'he saids' or 'she saids' after characters speak? This can ruin dialogue.
- Is there enough dialogue in the work?
- Do certain characters use favorite expressions or words?
- Do characters talk differently when speaking to different kinds of people? They should, for this reflects real life.
- Does the prose of the work follow the advice of Flaubert, the French writer? He said, 'If the prose does not follow the rhythms of the human lungs, then it is not worth a damn.'

Every fictional work you read with dialogue in it can be put through the above ten questions test. If you can answer yes to each question, then the dialogue is very likely to be effective.
In a fictional work titled 'Irony', I needed my lead character to explain why he had decided to make a drastic change in his life. After doing the same work for thirty years in Iowa, Boris Trent was determined to move to another state. How did I come up with what he should say? I simply visualized him explaining to his employers, and listened to him saying it in his own words. He then chose the right words.
Here is what he said:

'I've been driving the same runs here in Iowa for thirty years. I need a change of scenery.'

His colleagues did not wish to lose such a loyal and well-liked friend, so they tried to change his mind. 'You don't know anyone in Georgia or Florida, Boris. All your friends are here in Iowa.'

Boris agreed. 'I know, I'll just have to make some new friends. I'm tired and bored of the same routine here.'

Lawrence, a husky, determined man, persisted. 'What you need is a vacation, Boris, not a complete move to another state. Take some time off and you'll feel better.'

More or less the same thing happens when Boris goes to visit his brother in Kentucky. The brother tries to talk him out of the move. Here are some excerpts.

'How about us driving over to Land Between the Lakes on Saturday?' Kent asked two days after Boris arrived.

'No thanks, I remember it well.'

'It's changed, Boris, there's more to see and do there now.'

'Maybe next time I get here.'

Kent frowned. 'Will that be another two years? What's wrong, Boris? What's bothering you?'

'Nothing.'

'Come on, I know my own brother. Tell me about it.'

Boris breathed a long sigh and slowly walked to a spacious window overlooking the patio of Kent's home. 'I'm just bored.'

'Bored with what?'

'With driving a bus, with the same runs, the same daily routine, the same scenery.'

'You need diversion. Why don't you move in here with me? I'll get you a job with my company.'

'Thanks, but I don't know anything about church directories.'

'They'll teach you. There's ten days of intensive training.'

'No thanks, Kent.'

LISTEN TO YOUR CHARACTERS

 Kent joined his brother at the window. 'It's Zelma, you still miss her.'
 'She was a great friend – not just my wife.'

On the last day of his visit, Boris tells his brother about his plan to move to Florida. All the way to the airport Kent tries to talk him out of it. Even at the gate, he attempts one last time to persuade Boris.

 'I still don't see what Florida has that Kentucky doesn't.'
 'No snow and ice for one thing.'
 'How do you know there's a job there?'
 'I checked with the company, and they've offered me a job driving the Tampa to Sarasota run.'
 'But you don't know anyone in Florida, Boris.'
 'So what, I think the change and new scenery will help a lot.'

The characters can whisper in your ear from time to time, providing you know them well enough, their motivations, problems, and goals.

Whenever one of your characters is questioning another, you will discover that the resulting dialogue is usually tight, and often more believable than non-questioning dialogue. This is one reason that detective fiction often reads well and maintains a kind of engrossing rhythm or pace.

When characters in fiction become this real for the writers who created them, they transcend the borders of the pages that tell their stories and take on the magic quality of whispering in the ears of their creators. You will know when you have reached that magic point in your writing. It is unlikely to happen often, but you will marvel at it when it does. Listen well in the evening breeze, in the early light of morning, and even in the rush of each busy day. Listen for their whispers.

16 The Key to Good Dialogue Is the Response

One rule of thumb regarding dialogue will help you every time you write it. Keep what each character says in one paragraph. When another character responds with spoken words, start a new paragraph.

People reveal themselves in what they say. Only by what they say, their words, can we know them. How someone says something contributes to the overall picture. What are their facial expressions? Do they make any gestures when speaking? Experts say there are 250,000 different facial expressions. Just taking the key emotions, there is the sad expression, the angry one, the surprised look, a face that registers fear, and the happy expression.

One way to get good dialogue is to pre-plan the spoken response of each character for that scene. By thinking it through rather than writing it as the scene comes, you will have more control of the total effect. And the right response is important; it brings the following advantages:

- It keeps the dialogue moving.
- It makes the dialogue sound more believable.
- It introduces new elements into the dialogue.
- It throws the ball back to the other character.
- It makes the scene read better as a whole.

In the following dialogue between Karen and Jill, two of my fictional characters, they are discussing the need for daily

exercise. Do you think the response of each sounds believable?

> 'What you call my slender figure isn't what it used to be. I have to work to keep the pounds off.'
> Karen laughed at that. 'Didn't I tell you a long walk each day is the secret?'
> Jill smiled. 'The trouble is I don't feel like I'm making any progress. It's hard work to stay even ... to keep the status quo. If I don't fit in a long walk every day my weight rises.'
> 'There's another answer you know,' Karen offered.
> 'What?'
> 'Just quit eating.'
> They both laughed. 'Sure, Karen, that would do it. Goodbye food, easy come easy go.'

John Braine, in *Writing a Novel*, offers another useful bit of advice. 'There is no need to put down everything which your characters would say in real life. Only put it down if it's essential to the story.' Braine clearly feels, as Charles Dickens did, that the fiction writer must dramatize, dramatize. 'Every line of dialogue must advance the story, have conflict within it.'

In the following, I needed to show the reader how important the Marine Corps was to an old-timer character who was on his way to Washington, DC, for a visit. I decided to have him meet another ex-marine on the way.

> 'Going far?' asked the driver just to his left.
> 'Washington,' Lou answered, not quite out of the drowsy state yet.
> 'I've never been there. Hope to some day. I hear there's a lot to see. That Lincoln Memorial must be something.'
> 'So they say. This'll be my first time.'
> They were now in the traffic of another city, and Lou seemed surprised. 'What town is this?' he asked.
> 'Nashville, Tennessee, home of country music and the Grand Ole Opry. That's Vanderbilt University on the right there.'

> Lou was surprised. 'I fell asleep when we left Memphis. Can't believe we're already in Nashville.'
> 'I can't believe it's been seventeen years since I got out of the service.'
> 'What branch were you in? asked Lou.
> 'Marines.'
> Lou leaned forward. 'Me, too, back in the Second World War. I spent most of my life in the corps. My father was a marine in the first war. Served in France. The Marine Corps was my life.'
> At the next light, the driver turned to Lou and offered his hand. 'I'm Sam Holloway.'
> 'Lou Carter, always glad to meet a marine.'
> 'Yeah, same here. You ever run into any marines you were with?'
> 'Not for the last fifteen years. My outfit scattered all over the world.'

My objective was to get the two characters talking about the marines, and the resulting dialogue achieved that goal.

In another work, I wanted to show a confrontation between four angry youths and a man named Moreau, one of my major characters. Notice how the responses keep the dialogue moving and introduce new elements plus conflict.

> The toughest looking youth, Sid Stewart, took several steps closer toward Moreau.
> 'All we asked for was a few lousy bucks. What's that to you, big ears?'
> Moreau ignored the youth and entered a small bookstore. The four youths waited outside. When Moreau came out of the bookstore, the four immediately approached him, forming almost a circle around him. Stewart was the first to speak.
> 'Hey, dummy, no swimsuits allowed in there.'
> 'Threw you out, didn't they?' said Eric Poole, the smallest of the four.
> Moreau started walking away, but Stewart blocked the way.

THE KEY TO GOOD DIALOGUE IS THE RESPONSE

'Don't come back here again.'

Then Stewart tried to push Moreau but suddenly he could not move. He stood there in the centre of the mall like a frozen snowman with one hand ready to push. He could still speak but was completely unable to move. Stewart yelled.

'What did you do to me? Let me go.'

In *A Christmas Carol*, when the third spirit visits Scrooge, Charles Dickens wanted his lead character to see and hear a group of businessmen talking about his death and funeral.

The spirit and Scrooge stop beside this group, and the spirit's hand points at them. Scrooge sees them and hears their dialogue. Notice how very effectively the dialogue communicates the low esteem in which old Scrooge was held.

'No,' said a great fat man with a monstrous chin. 'I don't know much about it, either way. I only know he's dead.'

'When did he die?' inquired another.

'Last night, I believe.'

'Why, what was the matter with him?' asked a third, taking a vast quantity of snuff out of a very large snuff-box. 'I thought he'd never die.'

'God knows,' said the first, with a yawn.

'What has he done with his money?' asked a red-faced gentleman with a pendulous excrescence on the end of his nose, that shook like the gills of a turkey-cock.

'I haven't heard,' said the man with the large chin, yawning again. 'Left it to his Company, perhaps. He hasn't left it to me. That's all I know.'

This pleasantry was received with a general laugh.

'It's likely to be a very cheap funeral,' said the same speaker; 'for upon my life I don't know of anybody to go to it. Suppose we make up a party and volunteer?'

'I don't mind going if a lunch is provided,' observed the gentleman with the excrescence on his nose. 'But I must be fed, if I make one.'

Another laugh.

'Well, I am the most disinterested among you, after all,' said the first speaker, 'for I never wear black gloves, and I never eat lunch. But I'll offer to go, if anybody else will. When I come to think of it, I'm not at all sure that I wasn't his most particular friend; for we used to stop and speak whenever we met. Bye, bye!'

This example shows how revealing dialogue can be when it is written by a master like Dickens. It is little wonder that he is the most popular worldwide novelist of all time.

Dickens does not simply tell the reader that Scrooge was not liked. The conversation of the businessmen cuts to the simple truth that nobody cares that the old skinflint has died. Dickens pulls out all the stops in these comments, especially when one of them remarks that he is willing to go to the funeral if lunch is provided.

Christopher Hibbert, who has written about the life and works of Dickens, has said that there is no other major novelist comparable with him. 'The more often he is read the richer and more profound does his work appear, the more imaginative the symbolism, the more real and vigorous that extraordinary world which he created out of the real world of Victorian England.'

Test of dialogue is to read it aloud. Then ask yourself the following questions:

- Does it sound real?
- Judging by what they say, do the characters come across like real people?
- Is character revealed via the dialogue?
- Is there enough dialogue, or too much?
- Are too many variations on the word 'said' used?
- Do the dialogue responses ring true or do they sound forced?
- Do characters pick up on the major words of others? This repeating of key words makes for more believable dialogue.
- Is it clear which character is speaking? If not, the dialogue needs to be rewritten.

THE KEY TO GOOD DIALOGUE IS THE RESPONSE

- Are there at least some sections of brief, tight dialogue?
- Does the dialogue presented advance the story?

All is not lost if you do not get enough favourable answers to the above questions. You can always redo the spoken exchanges between characters until they are much stronger and more believable. The best writers rewrite the dialogue sections of their work until they feel they cannot improve them any more.

17 The Speech Habits of Ordinary People

One of the most important things to remember about dialogue is that characters must talk and say their words like real people. They do not talk in a flowery, strange or outlandish way unless there are key reasons for it.

The two waiters in Hemingway's story, 'A Clean, Well-Lighted Place', sounded like real waiters. Consider a few lines of the dialogue:

'He stays up because he likes it.'
 'He's lonely. I'm not lonely. I have a wife waiting in bed for me.'
 'He had a wife once too.'

Hemingway was a master of such tight dialogue exchanges. This exchange of comments and statements is what most people would expect. Hemingway presents the waiters' speech as you might expect it to be when an old man wishes to stay on.

In a fictional work I have still not finished, I have to show two young teenagers walking home by a forest and sharing their scared reactions to what they hear. In preparation for this, I talked to some young people, read some of their magazines, and listened to as much of their speech patterns as possible. Here are some excerpts from this work:

Ken, a thirteen year-old with freckles, came racing up to the boulder. 'What was that, Rick?'

'I don't want to find out ... from the sound of it. Come on, let's get moving.'

'But what could it be?'

'Some animal caught in a trap in the woods.'

'Nobody has any traps out there,' said Ken.

'Maybe they do. How do we know? Maybe the animal's hurt itself some way or been attacked.'

'Why don't we check it out?'

'It's too late. And besides, we don't even have a flashlight, dummy.'

Ken picked up the cadence of Rick's step. 'Guess you're right. Let's come back first thing in the morning and see what we can find.'

'I can't tomorrow. Maybe Sunday.'

'Listen, Rick, it's stopped now.'

'I know. The howls quit five minutes ago.'

They walked in silence for half a mile and felt relieved to hear only crickets, the flowing water in Mayhew's Creek, an occasional dog barking and the familiar, ordinary night sounds.

As they neared the area closest to the forest, Rick, who was two years older than Ken, saw the moving branches and quickly warned his friend.

'Hurry Ken, speed it up.'

Later in the work, Ken's mutilated body is found in the middle of the forest. The office of the police chief, Wilson, is filled with reporters. To capture the way Wilson would respond to this media circus, I observed some police officers in action, got some notes from television dramas, and put myself in Wilson's place.

I followed John Gardner's advice to see through the eyes of your characters, put yourself in their shoes. This is how I made Wilson respond:

Suddenly, Wilson whistled to get everyone's attention. Then he answered their questions with one response.

'We've tripled the patrol cars, and I've got men all over town in and out of uniform. If this thing is still out there, we'll get it. I've got a dragnet around this town tighter than the last stock market crash. There's no way this maniac is going to kill twice in my town and get away with it.'

'Do you have any leads?' asked a reporter from the *Chicago Tribune*.

'All I can say is that we're working on it around the clock. Now would all of you please leave. I want some order back in this office. Please go on about your business and give my people a chance to move on this latest killing.'

Three days later, in the evening, Rick calls at Wilson's home.

'Hi, Rick,' Wilson said, leaving the door open. 'I'm afraid this is a bad time for a visit. I'm thinking of resigning in the morning.'

'No, chief!'

'Maybe someone else can find the monster. The mayor seems to think so.'

'What does he know? Nobody can replace you, chief.'

'Thanks, kid, but my men have searched this town inside out without finding a single lead. The monster if there is one, must have the best hiding-place around these parts.'

'Chief, I spent the afternoon watching the film crew down at the lake.'

'Interesting, I bet.'

'I got an idea. I ... I think it might help you.'

'Sure, Rick, whatcha got?'

'Lydia Rosemont ... you know ... the lady who makes predictions and lives in the mobile home park just out of town.'

'What about her?'

'Why don't you talk to her, chief? Maybe she could help.'

'I appreciate the thought, Rick, but I don't think she's very

accurate any more. Besides, I've heard she's usually too drunk to make predictions or do much of anything.'

Notice that the idea Rick brings to the police chief leads to a bit of intriguing dialogue between them.

A bit later Rick goes to see the psychic. The old woman is in a heap on the cluttered floor. Rick guesses she must have tripped over one of the piles of books that are stacked everywhere. He helps her up, and she begins to yell. For this dialogue I talked to a number of psychics and actually attended a psychic fair. I walked around the rooms and heard parts of conversations going on between psychics and paying customers. This helped me a lot when writing the following dialogue:

'Get out, I don't need any help.'

'Are you hurt, Mrs Rosemont?' asked Rick.

When she realizes he was just a young teen, and wasn't going to leave, she calmed down. 'Just too much to drink, boy.'

'Do you have any coffee? I can get you some.'

After three cups of coffee, Lydia felt good enough to answer Rick's questions.

'Mrs Rosemont, you know about the murders in town. Chief Wilson may resign, and I just thought you might be able to help.'

'Ridiculous, how could I help him?

Rick smiled. 'You know ... since you're a psychic ... I thought you might know something that would help us find the monster's hiding-place. It killed my friend Ken.'

She laughed and then coughed. 'I used to have second sight, boy, but I've lost most of it now. If you don't use the gift, you lose it. Remember that.'

'What?'

'Psychic talent, boy, knowing the future.'

'Would you try anyway, Mrs Rosemont?'

The frail, white-haired woman leaned her head back on the sofa and appeared to go into a trance. She was silent for

several minutes. Then she sat up straight and looked at Rick.

'The newspapers didn't want to believe your story that the killer is a monster, but you were right about it. It is a monster. The beast can't help it. It has to kill because of an ancient curse.'

'Then it was a werewolf that killed Ken?'

'Who is Ken, boy?'

'My friend, the first one the monster killed. Ken and I heard it howling in the forest.'

The old woman frowned. 'Yes, it's a werewolf. It keeps its human form until the full moon brings on the change into a beast. Once changed it must kill.'

"I ... I never believed they really existed,' Rick said.

'You saw it with your own eyes. At least that's what the paper said. Did it look like a werewolf?'

'Well, it was dark and we were running, but it had claws, big teeth, and hair all over.'

It may be a bit melodramatic, but I decided to go with it after rewriting some of it and making several changes. I tried to use a similar speech pattern to the ones I heard at the psychic fair. People paying for readings asked the psychics various questions, and I tried to capture the same rhythm and pattern.

In John O'Hara's *From the Terrace*, Alfred Eaton's Wall Street employer had to sound like a magnate when he said something. Every time he speaks it is with a voice of authority, experience, a lifetime of building wealth. The speech pattern of this character and others in the same novel are right on target.

Mary St John, Alfred's unfaithful and complaining wife, also has a set pattern to her reactions and remarks. I do not know who O'Hara patterned his characters after, if anyone, but they came across as very believable indeed. I have a hunch that he patterned the character of Natalie after his own wife. The contrast between Mary St John and Natalie is remarkable.

Wherever you go, whatever you do, always be alert to the speech patterns around you. In stores, meetings, offices, on planes, and everywhere else, listen for the speech patterns of

ordinary people. Try to catch the rhythms and pulse of the way people from all walks of life communicate. Then you can draw from them whenever you write dialogue for your fiction.

18 Silence

Real dialogue, the kind we might overhear in the street or on a train, is messy: a good percentage of it is made up of 'ers', 'umms' and pauses. Therefore, just as we can't write down everything that happens to a character, we should not attempt to transcribe real conversation, even for realism's sake.

If, as the saying goes, 'a picture paints a thousand words', then silence sketches countless emotions. In a world that asserts itself through words as communication, it is all too easy to dismiss the power of silence; but, just because character A is silent, it doesn't mean they are not communicating with character B. If someone is trying to grab your attention without words, then you might look at their eyes to see the expression, or watch their hands, or study them for some other physical clues. In other words, you adapt to forms of communication other than basic addresser-addressee worded dialogue.

When we examine uses of silence in everyday life, we often look out for body language to tell what someone is actually feeling. Observing subtle physical gestures can allow the reader to interact with, and make judgements on the characters, as though they were real people. In George Eliot's *Middlemarch*, Sir James Chettam hears important news about Dorothea Brooke, with whom he is in love:

'Engaged to Casaubon'.
Sir James let his whip fall and stooped to pick it up.

Silence is often a symbol of submission and defeat. Women, for

example, are most often forced into silence. In Shakespeare's play *Coriolanus*, the famous Roman hero acquires his name through the defeat of the Volscian town Corioles, his battle cries fiercely demanding all his troops to fight.

> Where is the enemy? Are you lords o' the field?
> If not, why cease you till you are so?

When, spurred on by underhand Tribunes, the crowds of Rome declare Coriolanus a traitor, he joins the Volsces in their fight. Knowing that Rome is under threat, Coriolanus's mother visits him to appeal. The eponymous tragic hero's eventual defeat is marked by submission and silence; before, his battle cries tore across countries and cities:

> [*He holds her by the hand, silent*]
> Coriolanus: O mother, mother! What have you done?

The brutal tragedy *Titus Andronicus* was banned for many years, considered to be too gruesome, and it is incredibly disturbing. It does, however, differentiate between Roman and Barbarian by use of language (rather like the Greeks), notably when two Goth brothers rape and mutilate Titus Andronicus's daughter, Lavinia. They cut out her tongue, preventing speech, and cut off her hands to stop her writing about what had happened, thereby preventing any retribution. But, although she is condemned to *verbal* silence, her ability to tell is not taken away. While her outward physical injuries are obvious, she cannot express what else has happened to her, and her father (Titus) is wrong when he says:

> Thy map of woe
> I can interpret all her martyred signs

Instead, Lavinia uses the words of Ovid's *Metamorphosis* to retell her sufferings, using another text, allowing herself to be read:

> She hath been reading late,
> The tale of Tereus. Here the leaf's turned down

The mythological story concerns Tereus who kidnapped his sister-in-law and raped her. Her sister tracks Philomel down, and feeds Tereus's children to him. In the play Titus Andronicus actually interprets the gap between Philomel's story, and Lavinia's 'martyr'd signs'.

Sometimes, saying very little, as well as being present throughout the action, gives a character incredible dramatic power. In the Greek tragedy, *The Libation Bearers*, the second of the famous trilogy named *The Oresteia*, a character called Pylades is present for 900 lines of the play (which is about 1000 lines long), and just stands on the stage. In the first of the trilogy, Orestes' mother had brutally murdered his father, and then taken up with another man. *The Libation Bearers* follows Orestes' indecision, as he tries to decide if he should kill his mother to avenge his father, while arriving on the scene with his friend Pylades. After much prevarication, Orestes finally turns to his companion and asks him what to do:

> What then becomes thereafter of the oracles declared by
> Loxias at Pytho? What of sworn oaths? Count all men hateful
> rather than the gods.

Pylades speech is essential, and his reasoning in accordance with the moral beliefs of the day (and Orestes does indeed murder his mother). Pylades' continual silent presence would not be so effective in a novel, but it is a very simple strategy to give someone more sway.

When we think about silence, we are immediately aware of what is not there: if an empty stage confronts us, then it lacks actors; a character who doesn't speak lacks words, but why? Perhaps they are overcome with emotion, too angry to express opinions, maybe confused, or just plain stubborn. These kinds of emotive thoughts and feelings manifest themselves in the act of not speaking. The reader comes to his own (albeit guided)

conclusions about those feelings. And in the most fundamental way, the reader feels a lot more pleased with himself. He has, after all, interacted with, and made a value judgement about your text and your character, assessing that character as he would a real person.

At times, we may have rather more unsavoury motives for silence; for example, we might be concealing something, and, often, silence is an effective tool for confusing the reader as well as the central characters.

> Seldom, very seldom, does complete truth belong to any human disclosure; seldom can it happen that something is not a little disguised or a little mistaken; but where, as in this case, though the conduct is mistaken, the feelings are not, it may not be very material.
>
> *Emma*

Willoughby conceals his true love for Marianne by ignoring her and marrying an heiress in *Sense and Sensibility*. Liaisons and secret engagements are revealed only too late, and the complete truth is masked by the heavy sound of *not saying*.

In *Anna Karenina*, Kitty and Levin's unusual declaration of love involves coded messages to avoid public recognition of their affection. The lovers' words are written, which is still a communication of sorts, and one which allows us to see into their souls and discover their feelings:

> For a long time he could not make out what it was, and kept looking up into her eyes. He was dazed with happiness. He could not fill in the words she meant at all; but in her lovely eyes, suffused with happiness, he saw all he needed to know. And he wrote down three letters. But before he had finished writing she read them over his arm, and herself finished and wrote the answer, 'Yes.'

Theirs is an innocent exchange of love vows, almost childlike in its simplicity. It begins with him writing with chalk on a board,

the contracted letters as symbols, and progresses to interpretation of meaning from Kitty's 'lovely eyes'.

Michael Ondaatje's *The English Patient* explores the physical and mental devastation through obsessive love between Katherine (who is married) and Almàsy. The signs of their passion and love manifest themselves in her physical violence towards him; the grief and guilt of betraying her adoring husband is hardly addressed, and instead, frustration pours from elsewhere.

> 'What do you hate most?' [Almàsy] asks.
> 'A lie. And you?'
> 'Ownership,' he says. 'When you leave me, forget me.'
> Her fist swings toward him and hits hard into the bone just below his eye. She dresses and leaves.

She silences him by her violence and by refusing to begin the discussion again, simply dressing and leaving in silence. This is an extremely powerful scene, in which no other words are needed. The author is *showing*, and through our interpretation and judgement, we, as the reader, are understanding the hurt that is marked by her not saying anything.

Just as the words in our everyday dialogues contain subtexts, hidden meanings, or frank expressions of honesty to be interpreted, so characters' facial expressions and actions become as important as words when silence prevails. And, with any kind of sign, the reader's interpretation of body language evokes another layer of textual meaning, where the body of the character becomes an alternative text to be read.

PART V
POINTS OF VIEW

19 Who Is Telling the Story?

Every story must be told from some point of view. One of the first things a writer must decide is who is telling the story. It is difficult indeed to proceed if you do not know who the narrator is. This is why it helps many writers to live with a fictional idea for a while before writing it, to give them time to learn whose story is being told.

There are three viewpoint choices open to a writer: first person, second person and third person. The second person meaning 'you', is so unusual that I would not worry about it. For most of your fiction writing you will be using either the third or the first person ... and most likely much more of the former. In fact, most books on the writing of fiction recommend that the third person be used, and this is the viewpoint I like best. Some novels use the first person, and we will take a look at the advantages of that viewpoint in the next chapter.

The Time Machine switches back and forth from the third to first person, which is unusual but one can well understand why Wells did this. When the traveller is moving through time in the machine, it makes more sense to use the first person. When he gets to the world of the deep future, and is discovering where he has arrived, the third person is the right viewpoint. An interesting point here is that if you tell a strong enough story, you can switch viewpoints and break all sorts of rules and get away with it.

But while you can sometimes get away with changing viewpoints, it is usually better not to do it too often. Switching the

point of view too much could confuse your reader and make it unclear who is doing what. In my western novel, about the man who rides into town bent on avenging the murder of his brother, I held to the third person viewpoint throughout, even though I must admit it was tempting to use the first person in the scenes where the main character was thinking, getting in some target practice or riding off somewhere.

In the novel *Cain and Abel* by Jeffrey Archer, the scene switches back and forth from brother to brother, but the third person is the point of view.

On the other hand *Rebecca* opens with the clear first person point of view: 'Last night I dreamed I went to Manderley.'

In my story about the wife who poisons her husband's coffee, because he has asked for a divorce, I could have chosen the first person. It might have been a compelling way to unfold the story from the wife's point of view – that is with the wife speaking as the 'I' narrator. I felt on the whole, however, that the third person would be clearer in certain parts of the story.

In *Fiction*, Rust Hills gives a summary of works of the imagination. 'Something happens to someone, who is changed by the action. The person who is changed the most is usually the viewpoint character.' If you decide at an early point who is telling the story, your point of view question will fall into place and be clear to you.

In detective stories, you may prefer to use the first person because it increases believability – at least many people feel that it does. In *Double Indemnity*, it is clear from the beginning that the narrator's voice is that of the main character in the drama. This narrator is dictating everything that happened into a tape recorder and trying to get through with it before he dies.

It will help you considerably to look at the novels and short stories that you admire. This will teach you the structure of good fiction perhaps better than anything else you might do. Read your favourite passages over and over. Ask how the author presents the viewpoint and who is telling the story. Some newcomers to fiction writing have even been known to type out

various passages from chosen works to get a stronger feel and understanding of viewpoint.

Another tip is that if your novel has a lot of characters in it, you are better off to stick with the third person.

Whatever fiction you read, just ask yourself the basic question: who is telling the story? That answer will guide you as you develop your own work. Think of point of view as the angle on the story and go from there.

20 First Person Narrative

> By telling you anything at all, I'm at least believing in you, I believe you're there, I believe you into being. Because I'm telling you this story, I will your existence. I tell, therefore you are.
>
> <div align="right">Margaret Atwood The Handmaid's Tale</div>

Many claim that the first person narrative restricts fictional development. It is certainly very difficult to keep the lines of action to one viewpoint only, and much easier to write in a third person singular perspective, when, for example, presenting an action scene, or making observations that the central character could not have noticed. With regard to the flow of the text, the *I* can become repetitive and boring, and the reader sees only what the narrator is able to observe. But this kind of construction is deceptively easy; although it might confine what you can say with your story, when used skilfully and appropriately, it can be an enriching and instructive technique, producing incredibly powerful fiction.

The fact that the first person narrative confines the writer means that it can also be a useful device to exploit, for the reader knows no reality other than that which the narrator speaks, and becomes at the mercy of another mind.

A good way to understand the power of first person narrative is by thinking about how we use it in everyday life. *I* refers to a person, but also to testimonies that we might make: how we declare *I* when we swear to something; maybe sign a police

witness document; make a vow (*I do*); or even write a last will and testament. All these have one common theme: they imply that the *I* speaking (the addresser), is stating a truth that the addressee should accept.

In fact, *I* is the most important form in what we call performative speech: that is, saying something that is also an action (like, *I promise*, or *I swear*). Think how powerful these words are, and now understand the potential for harnessing it in fiction.

Eighteenth-century fiction observed a vogue in the epistolary novel that used realistic correspondence between different characters to construct a story. The most famous of all was *Clarissa* by Samuel Richardson, and it was this book that started off the whole trend. The million words of this massive text were originally comprised solely of letters exchanged between Clarissa and her family and friends, Samuel Richardson posing only as an editor who had accidentally stumbled upon the mass of correspondence. The story is very simple; Clarissa Harlowe's grandfather bequeaths his fortune to her, much to the envy of her siblings. Clarissa immediately hands over her fortune to her father, and after striking up a frowned-upon correspondence with the rakish Lovelace, is immediately forced to marry the infinitely disagreeable Mr Solmes. After begging her family to release her from the wedding, Clarissa runs away with Lovelace and this has tragic consequences.

Rather than restrict viewpoint, this kind of fiction actually allows for every character to have their say and, like in Poe's 'The Tell-tale Heart', it is the reader who is left to evaluate the character's actions. The *I* form also worked to create an illusion of forensic reality, and many people believed *Clarissa* to be a real life correspondence, themselves interceptors of the letters:

| **Addresser** | **Message** | **Addressee (1)** | **Addressee (2)** |
| *Clarissa* | *Help!* | *Anna Howe* | *Reader* |

Without any help from an overseeing narrator, the readers become the impromptu addressees, and are forced to make their

own judgements, and they do this by interpreting information provided by:

- What the characters admit to/confide in about themselves
- What characters say to others
- What others say about the characters.

The polyphony of voices in *Clarissa* creates a realistic setting, one which the reader is continually challenged to interpret. In this way, Richardson's portrayal of Clarissa has many nuances to it, formed by reader interpretation. The first voice supports the view of a blameless angel, weak and feeble, buffeted by the cruel blows of her jealous relatives and the dastardly Lovelace:

> I would, if I could, oblige all my friends [relatives] – but will it be *just*, will it be honest to marry a man I cannot endure?

Gaining sympathy by claiming she can't (rather than *won't*) obey, Clarissa is no exemplary symbol. Instead, like human nature, and despite being called angelic, she shows another side, especially in correspondence with her lively friend Anna Howe, in which her writing is characterized by a perky wit:

> ... my poor sister is not naturally good-humoured. This is too well-known a truth for me to endeavour to conceal it, especially from you. She must therefore, I doubt, have appeared to great disadvantage when she aimed to be worse tempered than ordinary.

Richardson discovered that the epistolary form gave his reader far too much freedom of interpretation; he had originally written *Clarissa* as didactic novel about moral standards, and the difficulties of teaching children properly. In fact, his reader's responses were at so much of a tangent to his original intentions, that he felt it necessary to publish another book accompanying *Clarissa*, with instructions on how to interpret it!

FIRST PERSON NARRATIVE

Remember Edgar Allen Poe's 'The Tell-Tale Heart', and how Poe used gaps in his narrative to aid reader interaction? Poe loved to use this narrative, and in many works he used the form to present characters who were shadowy and doubtful; in the case of 'The Tell-Tale Heart', the narrator and central character is completely insane, compelled to murder an old man because of his 'Evil Eye'.

> True! – nervous – very, very dreadfully nervous I had been and am; but why will you say that I am mad?

Because this occurs at the start of the story, the murderer is clearly addressing someone, but not the reader:

Addresser	Message	Addressee (1)	Addressee (2)
Murderer	*Denial of insanity*	*Voices in head*	*Reader*

The reader, although indirectly receiving the message, is still an addressee, and when prompted to doubt the narrator's mental stability, quickly realizes the truth. Using the first person narrative in dealing with the dark side of human nature can be incredibly effective, the reader taking on role of confessor to the criminal's misdeeds. By interacting with the text and ultimately the murderer's thoughts, the reader's judgement is all the more powerful because he has been given hints to create the ideas himself. Just imagine what the narrative would have been like had we been told that the murderer was completely doolally, was driven to distraction by the voices in his head, and how those voices and his conscience compelled him to own up to his crime.

The Handmaid's Tale presents another version of the 'found' text of the eighteenth century, and also taps into the oral tradition that helped pass on our fairy tales. From medieval times onwards, the oral tradition that existed before mass printing popularized the book as we know it today.

Set in the post-nuclear war future, *The Handmaid's Tale* tells how America is being ruled by a reactionary religious leadership who have completely restructured society according to their

interpretations of the Bible. The narrator, Offred, is a handmaid to a commander and has been assigned to breed in order to replenish the ailing human population, which is slowly dying from toxic poisoning. The handmaids are denied access to books, and live without warmth or friendship, hated by the commanders' barren wives and narrow-minded servants. Just as in *Clarissa*, Offred's isolation is marked by her narrative, her loneliness tangible. And, like that novel, Offred's need for someone to listen coincides with our 'discovery' of her words; for if she is speaking, surely someone will hear, 'I tell, therefore you are.' Because we know only as much as she does, her illegal fraternization with the commander (and then his chauffeur) could mean a death sentence at any moment, and she is constantly alert to the spies watching her:

> I freeze, cold travels through me, down to my feet. There must have been microphones, they've heard us after all.
> Ofglen, under cover of her sleeve, grips my elbow. 'Keep moving,' she whispers, 'pretend not to see.'

Having reached the Historical Notes in this novel, we realize that the narrative was taped onto various cassettes and smuggled out of Gilead. These Historical Notes do for the novel what prefaces do for eighteenth-century novels.

A 'found' text with no conceivable or secure author was an important feature of existentialist novels, like those by Jean-Paul Sartre. Existentialism argued for the *now* of human beings, how we exist in the present, and are solely responsible for our own future. This means that, for those who truly believe that life must have a meaning, the despair that results from the sudden realization that they must work for it, and may, therefore, never find it, is all consuming. The terrible weight of responsibility, that man is nothing over and above the sum of his choices, produces a kind of nausea, a terrifying angst about life. Knowing his own life counts for nothing, the author of *La Nausée* forever searches for that magical occurrence:

> Perhaps one day, thinking about this very moment, about this

dismal moment ... I might feel my heart beat faster and say to myself: 'It was that day, at that moment, that it all started.'

Bridget Jones' Diary has popularized the epistolary form for the twenty-first century female reader. Disclosing feelings, emotions and insecurities and weight problems in witty fashion, the narrator displays her 'me against the world but not against man' attitude. Addressing her diary, the reader assumes status as a confidante, a trusted friend (just as the eighteenth century-reader became an editor of *Clarissa*), and the book creates an illusory presence of a living, breathing person. Intimacy, something we all lack in this society, is provided in such diary form.

Film narratives are often used as a guide, 'voicing-over' the action in an attempt to emphasize aspects of the picture we may not have grasped. But this is a different kind of medium, trying to get the best out of both worlds; because action is already portrayed, and we don't interact through the character's eyes, but observe the central character interacting with others, the narrative seems superfluous. Imposing an *I* form on an already third person narrative undermines the power of both. Films like *Blade Runner* have benefited from a director's cut that removed the 'dimwits in the dark' voice-over, and allowed his film's atmospheric beauty to surface out of the action.

However, sometimes such a narrative can work. One of the most powerful uses of an equivalent *I* narrative in film was featured in *The Blair Witch Project*, whose realism initially invoked (familiar) rumours of it being a true story. This authenticity stemmed from the lack of narratorial 'eye' (in most films the omniscient camera provides this). The video tape, left by a group of students investigating the rumours of hauntings in their nearby town, was made entirely by themselves; they spoke into the camera, recording it in diary form.

So who are the addressees? The audience. The film left cinema-goers terrified, because they underwent a similar reaction as the eighteenth-century readers of *Clarissa*: they had intercepted the message and become impromptu addressees, both directly receiving the terrified characters' feelings, and also

viewing the situation from an alternative eye. In *Blair Witch*, when they run in the dark, the camera (and the audience) feel as though they are running too, experiencing the visceral reaction to the danger surrounding them. Isolated with only their camera and each other, this kind of cinematic *I* form intensifies the characters' isolation, making them far more vulnerable, and letting them imagine what the Blair Witch looks like.

With only the voice of an often unreliable narrator to guide him through the story, the reader falls back on the instincts he uses in real life; he sifts, interprets, judges, and draws conclusions from the gap between what the narrator says, and what he means. To an extent, first person narrative uniquely allows the reader to use his judgement and transcend the limits of the character narrator who is telling the story.

21 Third Person Narrative

> Your pier glass or extensive surface of polished steel made to be rubbed by a housemaid, will be minutely and multitudinously scratched in all directions, but place now against it a lighted candle as a centre of illumination and lo! The scratches will seem to arrange themselves in a fine series of concentric circles round that little sun.
>
> George Eliot, *Middlemarch*

Part of the magic of reading fiction is knowing that you are communicating with an author who sat down and wrote maybe two, or perhaps two hundred years ago. Regardless of time, you are keeping the narrator's voice alive in your head, and with the fictional narrator, no narrative technique is as realistic and tangible as third person. It is also a great responsibility. George Eliot's candle/pier glass motif is now a very famous image employed to describe the role of the narrator; for, if the character is the candle, and the circular scratches the events that happen to that character, then the narrator must be the person who decides:

- Where to hold the candle
- What particular events to choose
- What the events are

Implicitly, the narrator would know everything about his creation, right down to each character's favourite colour, or most hated food; therefore he would also know how that particular story would end. This authorial voice is often referred to as

the 'omniscient narrator', and, when we accept the author's world, we inherently trust the narrator/author to be our guide.

William Makepeace Thackeray is one of the most famous omniscient authors, whose serial novels were vastly popular in Victorian England. His narrative voice often interrupted the natural assumptions a reader might make when interacting with his text. In other words, our inclination to like, sympathize or identify with a character is automatically lost when the author continually inserts his opinions about that character:

> Little Amelia, it must be owned, had rather a mean opinion of her husband's friend, Captain Dobbin ... she liked him for his attachment to her husband (to be sure, there was very little merit in that).

The author has inserted his own point of view here, so, just as he is telling the story, he also presents personal opinions of the characters and their actions. This leaves the reader very little room for his own observations and judgement. The author acts as a god, that is, the person who not only narrates but speaks to his reader, both informing their opinions and the text. When reading *Vanity Fair* it is almost impossible to immerse oneself altogether in the story, because of the continual authorial interruptions.

Of course, all books have beliefs shaping them, but not all offer such obvious comments. In *Anna Karenina* Tolstoy guides the reader towards assumptions, and does not actually say what he thinks, but instead makes his characters show it. In this excerpt, a group in the fashionable salon are gathered for the evening:

> Seeing that while the Princess Myagky was speaking everyone listened and the conversation round the ambassador's wife stopped, the hostess turned to her in the hope of drawing the party together.
> 'Won't you really have any tea? You should come over here by us.'

> 'No, we are quite comfortable where we are,' replied the ambassador's wife, with a smile, and she resumed the interrupted conversation.
> It was a very pleasant conversation. They were disparaging the Kareninas, husband and wife.

Tolstoy does not directly criticize the hellish atmosphere of the society salon; he lets us reach this conclusion by guiding us towards it.

The most popular commercial fictional use of third person narrative shares many similarities with first person narrative; it allows the reader to see into the mind of one character at a time, and one character only, but can also allow the kind of dramatic irony achieved through a more complex use of narrative. In this way, the reader is allowed an important insight into the character's mind; not only does he see what the character thinks, he also is witness to what the character does not understand about himself. This is a very powerful method of presenting thought processes, as in *Anna Karenina*, when Anna begins her slow decline into despair, as she watches a couple walk along:

> Anna saw clearly that they were bored with one another and hated each other. Nor could such miserable creatures be anything but hated.

This has a lot in common with the very first source of third person narrative that we learn as children, which is the fairy tale. These, as we have already seen, were traditionally passed on orally, and parents and religious guardians used this form of narrative to teach children about morality. Whereas the actual narrator would vary every time a fairy tale was presented, the implied narrator, or the moral attitude shaping the story and its aims, would still remain. So, we have Little Red Riding Hood straying from the path and she is punished accordingly; with little characterization, no sense of whether the girl was scared or sad, and just an interesting plot. We are, therefore, being taught by example.

Now, what about other uses of the third person narrative outside of fiction? The Bible, historical documents and newspaper reports all use this construction as a simple form of commentary. History wouldn't work in the *I* form because it would appear to be a personal anecdote, and not the distanced commentary of an apparently neutral observer.

So, in the same way as first person narrative suggests personal truths communicated by author to reader as equivalent human beings, third person narrative is like someone on a higher plane telling the listener about events that have happened. Just by *observing*, the reader would be presented with an unidentifiable voice, whose facts (and not his argument) would persuade and inform.

Third person narrative is therefore the most versatile construction open to the writer; it is possible to see into character's minds, keep the reader in suspense, and allow the reader the kind of multiple viewpoints only really feasible in types of epistolary novels like *Clarissa* by Samuel Richardson and *Lady Susan* by Jane Austen.

Many eighteenth and nineteenth-century novels featured an author who would directly refer to, instruct and often patronize his reader. In this kind of fiction (think Jane Austen, Thackeray, George Eliot, Dickens), the author rules over an organically whole world; a fictional universe in which the author and the narrator are one and the same.

Jane Austen used third person narrative in very creative ways, weaving in and out of her characters' minds, whilst observing and commenting on their situations. Whereas superficial reading will indicate the use of third person, the ways in which it can expand on a character, theme or argument are very important.

Here is an excerpt from *Sense and Sensibility*, in which the activities of the Miss Steeles are described, with some irony, as they entertain Lady Middleton and her children:

> With her children they were in continual raptures, extolling their beauty, encouraging their notice and humouring all their whims; and such of their time as could be spared from

the importunate demands which this politeness made on it was spent in admiration of whatever her ladyship was doing, if she happened to be doing anything, or in taking patterns of some elegant new dress, in which her appearance the day before had thrown them into unceasing delight. Fortunately for those who pay their court through such foibles, a fond mother, though, in pursuit of praise for her children, the most rapacious of human beings, is likewise the most credulous. Her demands are exorbitant; but she will swallow anything; and the excessive affection and endurance of the Misses Steele towards her offspring were viewed therefore by Lady Middleton without the smallest surprise or distrust.

Did you notice several viewpoints here? From the very first line to 'unceasing delights', Austen acts as a mere observer, watching as the young women fawn upon their intended victim. She describes their over the top actions with tongue firmly in cheek. But her narrative tone changes as soon as she gives a general opinion of 'those who pay their court through such foibles'. From this point, Jane Austen eases into omniscient narrator mode, and reads her Lady Middleton character's mind, judging, 'without the smallest surprise or distrust'.

George Eliot created a complete provincial world in her fictional *Middlemarch*, and with it invented over seventy major and minor characters who were its inhabitants. Clearly this would not have been possible in first person narrative, as the reader gets a taste of just how claustrophobic a society it really is by being immersed simply as another onlooker. Eliot also transforms herself into judge and ruler of the characters' lives, sometimes guiding the reader imperceptibly to the required response by reasoning with them in the judgement of certain characters:

> Poor Mr Casaubon felt (and must not we, being impartial, feel with him a little) that no man had juster cause for disgust and suspicion than he.

Modern novels don't often get away with such an opinionated narrator, who assumes he may tell his reader what he should be thinking. In this way, the most common third person narrative has become the third person singular viewpoint, in which the narrator is just a siphon through which the story and all accompanying observations pass. For, in this cynical, media-saturated twenty-first century, people are better informed than ever, and can judge for themselves. So, you just can't get away with telling people your version of what they have probably thought out (or seen a documentary on) themselves. It began with classic realist novelists, and grew into modernism, and out of this springs the novel of today. Margaret Atwood, who used first person narrative so effectively in *The Handmaid's Tale* used third person narrative extremely well in *The Robber Bride*. In this novel, three old college friends – Roz, Charis and Tony – are reunited by the manipulations and betrayal of another friend, called Zenia. Zenia never has her say directly; instead, a picture is gradually constructed by three narratives, and Zenia's lies are finally exposed: 'She was on no side but her own.'

It is possible to understand trends in narrative by observing the social conventions and cultural identity of the day. As we have seen, modern novels objectify the narrator as 'man alone'; he is isolated, and in this world of technology and ever dissolving values, finds himself facing the world alone. Contemporary fiction (bordering on the post-modern) really focuses on the *now* of the narrative. A third person narrative in past tense offers a sense of security; that the narrator tells us of the past immediately suggests the existence of a future. The organic whole of the world implies community – that the characters are part of something bigger, a world which is also occupied by the reader.

PART VI
STYLE

22 A Brief History of Style

Defining why we like a novel or a particular writer has a lot in common with the kind of judgements we make about people. When people you know have style, then more often than not, they have something about them that sets them apart from others. The *je ne sais quoi* about Audrey Hepburn depended upon many elements; her inner beauty, her wonderful figure, her fabulous eyes, her elfin magnetism. It was these details that drew people to her as a whole individual.

But of course, the most natural answer to the question 'Why do you like that woman?' or, for our purposes, 'Why do you like that book?' is simply 'Because I just do'. This part of the book will attempt to negotiate the veritable minefield of style by exploring the nitty-gritty of writing fiction, or, in other words, the way you wear that hat.

If there are similarities between a person's style and a novel's style, then we can imagine that novels, like the people writing them, conformed to or broke the fashions and traditions of that day. There are a multitude of ways to explore style, and in the next chapter we'll examine some more technical aspects of writing. But for now, we'll look at a constant to test style: the universal of love, and, more importantly, happy endings in marriage.

Folk tales, especially fairy tales, usually ended with the prince marrying the princess, or something along those lines. In other words, social unity was the aim; the coming together of two

people who have undergone conflict and struggle, and who reasserted the traditional values of their community. Fairy stories – as opposed to myths on a grander scale – did not concern themselves with greater themes of Gods and the Fates; instead they are peppered with good and bad fairies (and witches), princes, and put-upon ordinary people being elevated to a grander status (i.e. Cinderella). They are wish-fulfilment fantasies, and obey the instinctive reaction in all of us to drift off to a better world if our own becomes too tough.

Escapism is what we often associate with fairy tales, and usually any novel that deals with love and marriage; we are usually assured a happy ending, one that unites the right people.

But how does this affect the development of style? Formally, academics like to think that the novel really had its roots in the eighteenth century; it was at this time that Defoe, Swift and their contemporaries presented texts as 'histories'. The departure from the meaning of history to the word story was in some way related to the rise of the novel form as eighteenth century readers were given access to works of fiction by the new printing press system. One of the most important works of that day was *Moll Flanders* by Daniel Defoe, whose work was touted as being about a woman:

> Who was born in Newgate, and during a life of
> Continu'd Variety for Threescore Years,
> Besides her Childhood, was
> Twelve Year a Whore, five times a Wife
> (whereof once to her own brother)
> Twelve Year a Thief, Eight Year a Transported
> Felon in Virginia, at last grew Rich, liv'd Honest
> And died a Penitent
> Written from her own Memorandums.

A very new fiction, Moll's first person narrative convinced readers that her testimony was completely true, and because of it, readers were drawn to her tale. In his preface, Defoe warned them of the lewdness, but placed responsibility for their reaction

22 A Brief History of Style

Defining why we like a novel or a particular writer has a lot in common with the kind of judgements we make about people. When people you know have style, then more often than not, they have something about them that sets them apart from others. The *je ne sais quoi* about Audrey Hepburn depended upon many elements; her inner beauty, her wonderful figure, her fabulous eyes, her elfin magnetism. It was these details that drew people to her as a whole individual.

But of course, the most natural answer to the question 'Why do you like that woman?' or, for our purposes, 'Why do you like that book?' is simply 'Because I just do'. This part of the book will attempt to negotiate the veritable minefield of style by exploring the nitty-gritty of writing fiction, or, in other words, the way you wear that hat.

If there are similarities between a person's style and a novel's style, then we can imagine that novels, like the people writing them, conformed to or broke the fashions and traditions of that day. There are a multitude of ways to explore style, and in the next chapter we'll examine some more technical aspects of writing. But for now, we'll look at a constant to test style: the universal of love, and, more importantly, happy endings in marriage.

Folk tales, especially fairy tales, usually ended with the prince marrying the princess, or something along those lines. In other words, social unity was the aim; the coming together of two

people who have undergone conflict and struggle, and who reasserted the traditional values of their community. Fairy stories – as opposed to myths on a grander scale – did not concern themselves with greater themes of Gods and the Fates; instead they are peppered with good and bad fairies (and witches), princes, and put-upon ordinary people being elevated to a grander status (i.e. Cinderella). They are wish-fulfilment fantasies, and obey the instinctive reaction in all of us to drift off to a better world if our own becomes too tough.

Escapism is what we often associate with fairy tales, and usually any novel that deals with love and marriage; we are usually assured a happy ending, one that unites the right people.

But how does this affect the development of style? Formally, academics like to think that the novel really had its roots in the eighteenth century; it was at this time that Defoe, Swift and their contemporaries presented texts as 'histories'. The departure from the meaning of history to the word story was in some way related to the rise of the novel form as eighteenth century readers were given access to works of fiction by the new printing press system. One of the most important works of that day was *Moll Flanders* by Daniel Defoe, whose work was touted as being about a woman:

> Who was born in Newgate, and during a life of
> Continu'd Variety for Threescore Years,
> Besides her Childhood, was
> Twelve Year a Whore, five times a Wife
> (whereof once to her own brother)
> Twelve Year a Thief, Eight Year a Transported
> Felon in Virginia, at last grew Rich, liv'd Honest
> And died a Penitent
> Written from her own Memorandums.

A very new fiction, Moll's first person narrative convinced readers that her testimony was completely true, and because of it, readers were drawn to her tale. In his preface, Defoe warned them of the lewdness, but placed responsibility for their reaction

entirely on their heads. In our standards, the love scenes are very tame:

> Thus the Government of our Virtue was broken, and I exchang'd the Place of Friend for that unmusical harsh sounding Title of WHORE. In the morning we were both at our Penitentials; I cried very heartily, he express'd himself very sorry, but that was all either of us could do at that time, and the way being thus clear'd, and the bars of Virtue and Conscience thus removed, we had the less difficulty afterwards to struggle with.

This is perhaps the most racy scene, and the several details of her other marriages have been cut altogether. Importantly, there is no suggestion of love here, just sex, and regret, and the 'less difficulty' of eventual repetition. Suggestion is an important tool here, and the reader, already enticed by the naughty detail, is free to make what he will of the gap left for him.

Understandably, readers grew tired of feeling gullible having been informed that the *Moll Flanders* was, in fact, not a biography, but fiction.

Epistolary novels like *Clarissa* developed from the original notion of art imitating life. By the late eighteenth century, the sentimental novel was heavily in vogue, and the now hilarious *Man of Feeling*, was exhibited as the proud exemplar of the emotional thinking man.

At the turn of the century, Regency novels began concerning themselves with the higher forms of human life, discussing marriage, and it was here that Jane Austen took her place in history; but not before ridiculing the sentimental novel first. The cultural restrictions of reserve and obedience limited Austen's heroines, and her characters had to conform to social norms in order to receive their happy endings. Darcy's initial 'ardent' declaration to Elizabeth in *Pride and Prejudice* is over quoted. This might make the female readers swoon, but it is the final declaration, that is reported, and not shown, that contains delicacy and beauty:

> Elizabeth, feeling all the more than common awkwardness and anxiety of his situation, now forced herself to speak; and immediately, though not very fluently, gave him to understand that her sentiments had undergone so material a change since the period to which he alluded, as to make her receive with gratitude and pleasure his present assurances.... They walked on, without knowing in what direction.

And then it was time for the classical realists, for whom the novel existed as a platform to exhibit their whole and organic worlds, of which they had the upper hand. For with Thackeray, George Eliot and Dickens, the 'loose baggy monsters', or multi-plot novels had begun.

Realism necessarily commented on life as a whole, and how the individual actively participated in his community. In *Middlemarch*, Dorothea Brooke negotiates her way through to affect the narratives of all other characters in Eliot's world, while Eliot narrates, proffering personal opinions. Her marriage to Casaubon fails, and she must re-evaluate her desires; wanting a superior to respect, she confronts the truth that her husband is nothing but a bitter old man, obsessed with the past, and unable to embrace the future. Jealous of his nephew, Will Ladislaw, he puts a codicil in his will forbidding their marriage. Their final reconciliation is accompanied by a thunderstorm:

> While he was speaking there came a vivid flash of lightning which lit each of them up for the other – and the light seemed to be the terror of a hopeless love.

Nature evinces the passion both deny, and they are shocked into epiphany.

Henry James, an important psychological realist writer, rewrote Dorothea's story in his novel *Portrait of a Lady*, in which his heroine Isobel Archer's woes are the central focus (unlike the multiplot of Eliot's original). He also employed the lightning scene, as well as several other key points of *Middlemarch*. In this excerpt, Casper Goodwood (the Ladislaw

figure) confronts Isobel with his love for her, knowing it to be reciprocated:

> He glared at her a moment through the dusk, and the next instant she felt his arms about her and his lips on her own lips. His kiss was like white lightning, a flash that spread, and spread again and stayed.

The modern novel as we know it began to evolve after Freud's momentous work on the individual mind. The modernist movement (Woolf, Joyce) prioritized the human being, discussing the thoughts in their mind, rather than their value to the community.

D.H. Lawrence changed the perception of love in novels. *Lady Chatterley's Lover*, *Women in Love*, and *Sons and Lovers* presented a peerless lens on society from his own background as a coal miner's son. His sexually explicit narratives were censored, but, like *Moll Flanders*, people's interest increased because of it. Portraying the love between people, not just of the privileged classes, Lawrence caused a sensation with his explicit style.

> He never forgot seeing her as she lay naked on the bed, when he was unfastening his collar. First he saw only her beauty, and was blind with it. She had the most beautiful hips he had ever imagined.
>
> *Sons and Lovers*

As social barriers melded, the psychological novel extended past the usual upper middle class, and even elitist opinions of the Bloomsbury groups, to a miner's son from Nottinghamshire – D.H. Lawrence. With such books as *Lady Chatterley's Lover* and *Women in Love*, D.H. Lawrence was to re-evaluate and finally break free from Victorian censorship, talking for the first time about how love *really* is for all classes.

As the two wars threw novelists back into thinking of community and structure in direct parallel with the human psyche, the

post-war writers returned to human nature as a subject, and explored man's own inner, spiritual conflicts. Gone was the community of Middlemarch and Wessex, and onwards to spiritual despair, documented by writers such as Graham Greene.

The 1960s saw the important development of the magical realist novelists, who beautifully intertwined the pathos and suffering of real people with inexplicable events that somehow made tangible their experiences.

Gabriel García Márquez's *One Hundred Years of Solitude*, young Meme Remedios's love affair with Mauricio Babilonia is marked by beautiful yellow butterflies, that flutter around his head, and enfold themselves around the one he loves, when they make love. Hiding the liaison from her family, Meme takes a bath every evening, when her lover visits her:

> Every night on her way back from her bath, Meme would find a desperate Fernanda killing butterflies with an insecticide spray. 'This is terrible,' she would say. 'All my life they told me that butterflies at night bring bad luck.'

The modern novel, as we know it today, sews together these styles, sometimes paralleling, sometimes ridiculing their ways. It is a rich tapestry from which we may draw great wealth.

23 Techniques of Style

Punctuation

People did not always punctuate; seventeenth-century Italy produced massive texts of run-on lines of endless words which must have frustrated the most patient of readers. Nowadays we have a number of marks that aid the clarity and flow of writing: comma, full stop, colon, semicolon, exclamation and question marks and so on. But, even our grammatical system today is a bit of a movable feast, and, when it comes to rules, a bit of subtle rule-breaking isn't impossible.

You can obtain basic grammar guides anywhere, so I won't bore you with them here, but remember that efficient writing begins with conscious use of consistent punctuation.

Charles Dickens wrote some pretty long sentences, often running to the size of paragraphs. Without his complex system of punctuation, his work would lack its original power. Here is one of the most famous beginnings of all time:

> It was the best of times, it was the worst of times, it was the age of wisdom, it was the age of foolishness, it was the season of Light, it was the season of Darkness, it was the spring of hope, it was the winter of despair.

The commas work to retain the fluidity of the contrasting elements of Dickens's world. Had he used a full stop, it would feel quite different:

> It was the best of times. It was the worst of times. It was the age of wisdom. It was the age of foolishness.

Now the pace of the statements is much slower and final, and, although related to the one before, does not formally relate each statement as a contrast. Instead, doesn't it sound rather muddled and stilted? Now see what happens if we insert a colon near the end of this chosen excerpt:

> It was the best of times, it was the worst of times, it was the age of wisdom, it was the age of foolishness, it was the season of Light, it was the season of Darkness, it was the spring of hope: it was the winter of despair.

The colon now makes the winter of despair the final overriding statement. All the dichotomous images and emotions that had gone before make up the final summary – that everything is in fact in despair. Finally, let's use lunulae to separate the contrasting statements. How does this change not just the sense, but the overall feeling of the piece?

> It was the best of times (it was the worst of times) it was the age of wisdom it (was the age of foolishness) it was the season of Light (it was the season of Darkness) it was the spring of hope (it was the winter of despair).

The lunulae somehow make the negative statements into an aside, a subcomment that seems to contradict the happiness of the first statement. The bracketed material is almost like a separate voice whispering the truth under the apparent reality of the optimistic words of the narrator.

Dickens used commas, not just to pause, but also to compare each statement against the other. Without the comma separating the contrasting thoughts, we read it as a breathless flow of commentary. As it is, the dichotomy of his world seems natural, and part of the strange concoction of life.

Modernist writers liked to use stream of consciousness to

depict the progress of their minds in thinking through problems and dilemmas. Here, the semicola act as a passage into the next related thought, for our minds work in this kind of tangential circularity. Notice how Virginia Woolf's train of thought is punctuated in this excerpt from *A Room of One's Own*, as she ponders aspects of life:

> I pondered why it was that Mrs Seton had no money to leave us; and what effect poverty has on the mind; and what effect wealth has on the mind; and I thought of the queer old gentlemen I had seen that morning with tufts of fur on their shoulders; and I remembered how if one whistled one of them ran and I thought of the organ booming in the chapel and of the shut doors of the library; and I thought of how unpleasant it is to be locked out, and I thought how it is worse perhaps to be locked in; and, thinking of the safety and prosperity of the one sex and the poverty and insecurity of the other and of the effect of tradition and of the lack of tradition upon the mind of a writer...
>
> *A Room of One's Own*

When we think, our general line of thoughts blend into each other; sometimes we suddenly jump to attention and wonder how we got on to thinking about something completely unrelated. Woolf achieves this wonderfully by her use of semicola, linking the first thought to the second and so on, so that she moves, quite realistically, from thinking first about something very specific (Mrs Seton's poverty), to the poor in general, then to women against men, and the whole tradition altogether.

Contemporary novelists often keep their sentences very short and terse. In J.M. Coetzee's *Disgrace*, economy is the word of the day:

> That is where he ought to end it. But he does not. On Sunday morning he drives to the empty campus and lets himself into the department office.
>
> *Disgrace*

Tense

In every day speech, we use quite basic tenses: past for talking about what we've done, what we could or should have done; present for what we're doing now; future for what we're about to do, and what we plan to do in the future. When someone reads a text, the tenses might work to befuddle, distract from and alternatively elucidate what is going on. Often, unless a reader has been tuned to pay attention, he won't have realized what tense your book was written in.

Actually, whichever tense you're writing in, your style slightly changes with it. The eighteenth and nineteenth-century authors used past tense to consolidate their historically accurate and realistic world. Their omniscience related to their knowledge of hard facts, and their credible comments and viewpoints, to their retrospective view on events.

This was a world in which characters were viewed in terms of the community in which they lived, rather than in terms of their personal problems, and the oppressive force of narrator and the currents pressuring the central characters related to a community-focused world. And, even in *Clarissa*, the letters were written in past tense, where things have already happened.

Modernist and existentialist writers changed all this by writing in present tense. Whereas a reader can assume an ending when the narrator uses past tense (an implication of a past is simultaneously a reassurance of a future), we cannot assume this when a character/narrator speaks to us in the present. In a way, we exist in the same time as they do and so they are exposed to similar dangers and insecurities as we are. As we have seen in the existentialist writer's use of first person narrative, present tense further isolates them from the community around them.

Isolation has translated particularly well to drug literature, where present first person tense reflects the central character's imprisonment in his own mind of addiction:

If ah don' move, ma tongue will slide down ma gullet anywat.

Ah can feel it moving. Ah sit up, consumed by a blind panic, and retch, but thirs nowt comin up.

Trainspotting, Irvine Welsh

Just as Sartre must take responsibility for his life, so Renton (above) must haul himself out of being alone in his drug-induced isolation to eke out a future.

We can compare two very different stylistic uses of tense in order to compare the communities and worlds they reflect; as the eighteenth and nineteenth centuries dictated community values, so the twentieth and twenty-first centuries portray separation from a fragmented society. The preferment of the individual coincides with his alienation from the community around him. It also relates to our own media-saturated age, where we are far more well informed. The fictional prose you write will reflect as much your style as it will the time in which your fiction is written; it is the beauty of language and the universal human spirit which will transcend time.

24 Diction

> 'Twas brillig, and the slithy toves
> Did gyre and gimble in the wabe:
> All mimsy were the borogoves,
> And the mome raths outgrabe.
>
> > 'Jabberwocky' from *Alice in Wonderland*
> > Lewis Caroll

Novels evoke a polyphony of voices. The words chosen for each character cannot be the same, and so words used by characters in speech, thought, or even narrative style do not really say anything about the author's true stylistic choice of diction. The critical theorist Mikhail Bahktin called this phenomenon 'heteroglossia' by which he meant that the novel form presented many different language images layered on top of each other. For instance, he says, when a character's poetry is quoted, the author would not be using imagery, or diction in the same way as a poet would; instead, he would actually be using that language in order to say something about that character. For Bahktin, the only valuable way to ascertain the author's true style would be to find the central point at which all other linguistic images intersected. Confused? Well, before the novel form, we had plays, and heroic verse (e.g. Paradise Lost), which did not delineate character differences as we know today. Thomas Malory wrote *Morte Darthur*, possibly one of the most misrepresented texts ever to have existed. Malory's version of the Arthurian legend was jam-packed with sex, adultery, lies and betrayal, and bears no resemblance to the soft focus adaptations

of today's cinema. What Bahktin saw in it was its representation of 'monoglossia':

> 'A, sir Launcelot, Launcelot! Ye have betrayed me and putte me to the deth, for to leve thus my lorde!'
> 'A madam, I pray you be nat displeased, for I shall com agayne as sone as I may with my worship.'
> 'Alas,' seyde she, 'that ere I syghe you!'

Without constant reference to whom is speaking, it would be difficult to distinguish between the characters (remember how the test of dialogue is to cover up the names and see who is speaking).

One of the problems with such assimilated characters is, in modern terms, the complete lack of psychological depth. The heroic poetry of Homer and Ovid also had stock quotes like 'grey-eyed Athena', and introductions such as 'dawn comes early with rosy fingers', that really do begin to grate after a while.

Diction, then, is probably the first method of in-depth characterization, i.e. not just what the character says, but also how the author describes him. In Chaucer's *The Miller's Tale* about the cheeky rogue Nicholas, who has a fling with his landlord's pretty wife, Chaucer has a nice word play on *hende* (kind):

> He plyeth Herodes upon a scaffold hye.
> But what availeth him as in this cas?
> She loveth so this hende Nicholas.

Epithets like 'grey-eyed Athena' and 'hende Nicholas' help to form characterizaton; Shakespeare was one of the greatest punners, his comic 'relief' characters often offering some of the more bawdy plays on words. Plays especially depended on differences in people, and Malory's equal prose where beggars and knights speak in the same high register would have been implausible.

Shakespeare's plays dealt beautifully with rhetoric versus truth – think of Polonius in *Hamlet* and Iago in *Othello*. In *King Lear*, the daughters of Lear are challenged to profess their love

for him; both of his older (less beloved) daughters wax lyrical for their love. This is jealous Goneril's contribution:

> Sir, I love you more that words can wield the matter;
> Dearer than eyesight, space and liberty;
> Beyond what can be valued, rich or rare,
> No less than life, with grace, health, beauty, honour;
> As much as child e'er loved or father found;
> A love that makes breath poor and speech unable.
> Beyond all manner of much I love you.

Her sister follows with a similar statement, until it is young Cordelia's turn; and her answer is 'nothing':

> Unhappy that I am, I cannot heave
> My heart into my mouth. I love your majesty
> According to my bond, no more, no less.

Much to Goneril and Regan's delight, Lear is enraged that his favourite daughter is not professing to be consumed with love for him. Cordelia's answer is balanced (no more, no less), the simple words contrasting with her sisters' hyperbolic declarations of adoration.

The power of rhetoric also features in Hamlet's publicly ridiculed love letter to Ophelia:

> O dear Ophelia, I am ill at these numbers. I have not art to reckon my groans. But I love thee best, O most best, believe it. Adieu.

Simplicity is the order of the day in Shakespeare's terms, and with a 30,000 word active vocabulary, had little difficulty in expressing his characters' feelings.

So, we may return to the painting metaphor: if words are painting, then vocabulary is the breadth of colour; some painters limit themselves to certain colours, knowing they have different meanings and so on; others express themselves wordily for a reason.

DICTION

Nowadays, writers such as Irvine Welsh embrace their home vernacular; he cleverly intertwines his narrator with phonetic word creations. With these, he distorts received pronunciation words, which helps to create sounds in your head. The key to reading Welsh is first of all to lip-synch it; after a while, you find yourself speaking fluent Glaswegian.

> The me that's crushin up the pills sais that death cannae be worse than daein now tae arrest this consistent decline.

Dystopian and post-modern novels often invent language in order to highlight changes in the future. In fact, a great predecessor to dystopian novels was Jonathan Swift's *Gulliver's Travels*, which constricted the use of language (proved to be dangerous to lungs) by using symbols.

Having devised a method of substituting objects for words, scientists silently go about their discourse – with comic results:

> I have often beheld two of those sages almost sinking under the weight of their packs, like pedlars among us; who, when they met in the street should lay down their loads, open their sacks and hold conversation for an hour together, then put up their implements, help each other to resume their burthens and take their leave.

George Orwell's *1984* came up with a similar linguistic version called Newspeak, which economized language and therefore excluded its beauty in order to control its citizens. Orwell uses contracted 'portmanteau' (blended) words to convey information economically:

> Times 3.12.83 reporting bb dayorder doubleplusungood refs unpersons rewrite fullwise upsub antefiling.

According to the dictatorship in *1984*, Oldspeak (our language now) was unsatisfactory in its precision in reporting Big

Brother's Order of the Day. The beauty of language, like that of the natural world, was denied.

Like Jabberwocky in this chapter's epigraph, portmanteau words sound credible because they are really a cut and paste job on words existing today. They are also onomatopoeic, relying on sound to help make sense. For example, Jabberwocky's 'slithy toves' sounds a lot like 'slither' which conjures up an image of slime and gunge.

A Clockwork Orange is famous for its strange language, that is, in fact, structured around Russian. The youth of the future speak this garbled language. In the following excerpt, Alex is being reintegrated into society, by shock-treating him against violence.

> They made a real pudding out of this starry veck, going crack, crack, crack at him with the fisty rookers, tearing his platties off and then finishing up by booting his nagoy plott....

The scene of extreme violence becomes rather ambiguous through Alex's viewpoint, because his words are used to describe the assault. In other words, through his eyes, the attack seems less horrifying, because the reader must undergo a process of interpretation before he realizes what is happening (rather like understanding the Jabberwocky). Only then does the victim's situation become frighteningly real. In fact, any glossary of *A Clockwork Orange* would probably spoil Burgess's original ideas for his use of diction, and instead of becoming completely alienated from Alex, we are strangely drawn into his world by his enigmatic words. The use of diction here, as in all of the fictional world, requires the reader's creativity, and our interpretation of the action makes us an active part of the writing process.

PART VII
CHARACTER

25 Every Story Is a Story About Characters

A writer's imagination and technique are used to create a fictional version of a person, who then becomes a character in the unfolding story. Believe it or not, novelist Leo Tolstoy had 500 characters in *War and Peace*, which took six years to finish. Tolstoy based his characters on people he knew, or knew about, but he used them only as basic models. He used his imagination to turn them into new people. Short or long, every story is a story about characters. What would *Gone with the Wind* be without Scarlett, Rhett, Melanie and Ashley, and their goals, problems, loves and actions?

In *Shane*, the main character tries to stop being a gunfighter. It does not work. 'You can't break the mould,' as Shane put it. Yet his effort to do so results in a gripping story. In Poe's short story, 'The Cask of Amontillado', the reader is hooked in the opening sentence, spoken by Montresor, one of the main characters: 'The thousand injuries of Fortunato I had borne as I best could, but when he ventured upon insult I vowed revenge.' The reader's attention and interest are immediately captivated.

The dictionary definition of a story is 'a narrative, usually of fictitious events, meant to interest, amuse or entertain a reader'. But how can this function, this objective of story, be achieved without one or more characters? Most stories relate events and experiences as they apply to a character.

A ghost legend I grew up hearing in Memphis, Tennessee, told

of a beautiful young woman who was seen a number of times, always at night, standing at a corner bus stop near Forrest Hill Cemetery in the rain. When offered a ride back to her home, she would climb into the car's back seat and give the address where her mother lived. But before arriving at the address, the woman vanished. This story had reportedly happened to several people who tried to drive the woman home. This legend haunted me for years until I finally wrote a story about it, changing certain elements but keeping the same description of the young woman. But how could it have been done as a story without the woman as the main character? The entire scope of it revolves around the young woman.

In a story by D.H. Lawrence, 'Two Blue Birds', the entire premise is given in the first two sentences: 'There was a woman who loved her husband, but could not live with him. The husband on his side was sincerely attached to his wife, yet he could not live with her.' Take the characters away, the woman and her husband, and there is no story. They are the story. Lawrence goes on to explain, within the first paragraph, how this couple felt eternally married to one another and very closely connected, yet unable to live together.

In 'The Birds', by Daphne du Maurier, woman delivers two love birds to a friend in a coastal town. The rest of this unforgettable tale proceeds from the gift of the birds. Here again a character's specific action leads to complications – birds out of control – and the rest of the story.

It is important to make your characters human. It is their development that moves the story on. In Victor Hugo's *Les Miserables*, everything proceeds from the main character's action of stealing a loaf of bread for sick child.

There are eight ways to present a fictional character;

- by the character's action
- by the effect of the character on others
- by what others say about the character
- by the character's speech
- by description

EVERY STORY IS A STORY ABOUT CHARACTERS

- by the character's thought processes
- by the character's reactions to others in the story and circumstances
- by the character's motives and traits

In *The Great Gatsby*, Fitzgerald shows a powerful sense of the quality of a character in the portrait of Gatsby. He is not totally bad, though he seems to be. Most of the eight ways to present a character in fiction can be seen in this novel. The story is advanced, for example, by the effect of Gatsby on others, by what they say about him, by his description, his motives and his actions.

Another example of how character creates and advances the story is the character of Alfred Eaton in John O'Hara's *From the Terrace*. Alfred's unhappy home life, and his strained relationships with his parents and first wife, are all he has known, so his later experience of walking into a very happy home, 'where the warmth did not just come from radiators', has a real impact on him and opens his eyes to what he has missed in life. Again, character leads to, complicates and advances the story.

In the words of John Gardner, a novelist who wrote several definitive works on the craft of novel writing, 'The wise writer counts on the characters and plot for his story's power.'

Jack Bickham, author of over sixty-five published novels, warns that 'without sympathetic people in your story, you might as well be writing a grocery list'.

Gardner offers more useful advice: 'The novelist ought to be able to play advocate for all kinds of human beings, see through their eyes, feel with their nerves, accept their stupidest settled opinions as self-evident facts (for them).'

Consider the following:

- Elise McKenna, an old woman in Richard Matheson's *Bid Time Return*, hands a watch to a young playwright and whispers 'Come back to me.'
- In O'Henry's 'Gift of the Magi', a married couple sacrifice their most prized possessions in order to buy each other a Christmas present.

- In *The Picture of Dorian Gray*, a young man gazes at his handsome portrait and offers his soul if he can remain young, while his portrait changes and grows old.
- Not liking his own time period very much, the lead character in *The Time Machine* finds adventure and happiness in the distant future.

These examples show that you may have a character with a goal, a desire, a problem, perhaps a determination to accomplish something or go somewhere. The story proceeds from that point, with all its complications and outcomes. But the characters come first. Creating and building interesting characters, caught up in all the fears, problems, loves, emotions and goals of life will evolve and develop the story.

The following guidelines should help you to build characters that will lead to absorbing stories or novels:

- Try to develop the ability to put yourself into your characters' shoes. See life through their eyes.
- Write and rewrite, then correct your work endlessly.
- Begin by describing the scene and then saying what the characters look like, their origins, habits, defects and ideas. Then proceed to tell the story.
- Believe strongly in your characters. If you do not, then start again.
- Remember that the best plots are often based on characters who are in conflict with themselves.
- Do a sketch for each of your characters, and include the following:

 name
 place and date of birth
 education
 health
 parents' names, ages, and present locations
 job background
 financial status

EVERY STORY IS A STORY ABOUT CHARACTERS

 marital status
 ambition
 awards
 hobbies

Learning to inhabit the lives of your characters will bring you the best chance of success.

26 Twenty-five ways to Create a Character

Here are some suggestions for triggering ideas whenever you seek to create a fictional character. The clues offered are aimed at setting up a stimulus, connection, or link in your mind, which will hopefully help you. Refer to this chapter when you seem to be stuck in your character creation.

Creating characters can be fun as well as work. Try to make bringing to life new people interesting. Play with an idea, try to visualize the character. Anything that helps you see this person will help. Here we go with twenty-five clues:

1 Start with a baby and what happens to him or her. I used the baby idea as a springboard, and it led to a good character and novel.
2 Create a character from an emotion. One example that comes to mind is the novel *Silas Marner*, by George Eliot.
3 Think of a character bent on going somewhere.
4 Try introducing an ambitious person. (Remember Macbeth?)
5 Develop a character from an historical event or era.
6 Think of a famous battle and create a character from that.
7 Observe ordinary people each day. Characters very often emerge from such observation.
8 Create a character in an unusual occupation.
9 A character might be a rebel.
10 A character might develop from a warning or danger.

TWENTY-FIVE WAYS TO CREATE A CHARACTER

11. A character could come from a memorable city, town, or village.
12. A character might have a strong desire to acquire something.
13. Think of someone who is out for revenge (Poe used this one a lot).
14. Use a character with a certain trait or quality.
15. Try introducing a character with a special talent.
16. Someone might be trying to improve his or her life.
17. A character could suffer from a handicap.
18. Someone might be bent on breaking a record.
19. Imagine a character who is lost, snowbound, surrounded by approaching fire or ambushed.
20. A character who has lost his or her memory could be an interesting starting point.
21. Think of someone in search of a cure for a disease.
22. You might have a character who is dedicated to helping young people.
23. Imagine someone in search of the perfect marriage.
24. Create a character striving to develop a skill.
25. You could invent a character who is gifted.

There are many more such ideas, but these should act as springboards for your own ideas and imagination.

To show you how these suggestions can trigger a writer's mind, here is an excerpt from a work of mine still in progress. I took the idea of an unusual occupation and created a character, a court jester, who is in love with Maria, the king's daughter. The story opens at a crisis in the jester's life.

> Many years ago, in a distant land, there lived a court jester who could make almost any person laugh. He had the gift of humour and was happy to spend his days bringing mirth and merriment to others. He thought of himself as good, jolly and successful. Then in one day the jester's life changed. He was ordered to leave the castle, his happy life, and Maria, the love of his life.
>
> When the jester rode out of the castle, he glanced up at the

west tower. Maria was waving goodbye. He thought she might be crying, but he could not tell for sure, being a bit near-sighted. He waved back at her and then rode through the gate to the open country beyond.

Maybe execution would have been the best thing after all, he thought. For now he knew not what lay ahead for him and whether he would ever return to the castle. He could only do his best.

My point in presenting this excerpt is to show you that anything can trigger your mind and lead you to the creation of a new character. Creating characters can be fun, and I enjoyed dreaming up the poor court jester and placing a series of obstacles in his path.

Fiction is people, and there are all kinds of characters waiting for some writer to give them life on the page. Listen to those that seem to speak to you, to whisper in your ear and tell you what they want to do.

Without overdoing it, it helps readers if you enable them to enter the thought processes of the main characters. This lets them understand why a character makes certain decisions, is in need of guidance, is angry, etc. Maybe a character cannot make up his or her mind about an important matter. If the reader is in on the thought processes, the story has more impact and there is a greater sense of being right there, in the character's mind.

And remember to introduce your main character soon – on the first page if at all possible. If the readers have to read too many pages before learning who the key person is, they are likely to become confused and perhaps stop reading. Your goal is to hook your readers quickly and draw them into the narrative. Sometimes there are good reasons why the main character does not appear at once, but all in all the sooner you bring them onto centre stage the better.

27 The Series Character

James Bond is probably the most famous series character of them all. Ian Fleming's first book was *Casino Royale*, in 1953, and the series developed from there. How did Fleming create such a terrific series? He had worked as a newspaper journalist, and during the Second World War he was assistant to the Director of Naval Intelligence. It seems clear that this background and experience helped him. It is said that he had access to British Intelligence, and one can only speculate on whether this triggered some of his ideas.

Features of the Bond series include beautiful women, glamorous foreign settings, plenty of obstacles for Bond to overcome, super cars that were sometimes rolling fortresses even with secret wings, some suggestive sex scenes, and an arch enemy bent on achieving some destructive goal or evil. Fleming's series skyrocketed after his third book, and the word went round that everyone was reading the Bond books, even President John Kennedy. Word-of-mouth is the very best form of advertising a book can have, and the Bond series is a good example.

There have been other successful series, though perhaps not of the same calibre as James Bond. Erle Stanley Gardner did tremendously well with the Perry Mason series. At the height of this series' success, a story circulated that Gardner had seven or eight secretaries typing at the same time. He would walk from one secretary to another, dictating the books as they progressed. Another intelligence agent who featured in a series was Sam

Durell. Its creator, Edward S. Aarons, called his books 'romantic adventure'.

If you want to try your own hand at a fiction series, you need a fresh, new hero. If you get it right, the advantage is that every new book brings new readers into the fold, as they are discovering the series for the first time. This helps to keep series books in print for long periods of time.

How can a writer come up with a series idea and a fresh hero to star in it? I personally think that travel can trigger such an idea. It has certainly happened to me. A foreign setting with different scenes, landscapes, cities, customs, language patterns, forms of transportation, can all trigger a series idea.

Publishers, editors, and agents still like the action adventure series – more so than the mystery series because it is more commercial. The usual character for such a series is a high-level government agent, usually operating secretly, who must report in periodically and keep his superiors informed. The good-versus-evil nature of many of these books is quite apparent. The conflicts of these series heroes are always strong and persistent.

But if this type of character does not interest you, and you feel the same about a mystery series, there is another possibility open to you – the western series. The late Louis L'Amour was one of the most popular creators of this type of series. His world was that of cowboys, rustlers, and Indians. Incredible as it may seem, L'Amour was a school dropout but a voracious reader. 'I spent those years [his first fifteen] reading everything in sight and walking the North Dakota hills with a rifle. Most of my study periods were devoted to tracing out routes on maps of the world that I someday intended to follow.' Halfway through school, L'Amour's father started earning more money, so he had no objections to the 16-year-old boy's leaving school. He became a globetrotter and on one trip he walked and rode a bicycle across India. He worked his own way, taking jobs as a circus helper, a tourist guide, a boxer, and lumberjack.

L'Amour's technique with his series was to place a character or group of characters into a certain situation and then go with their reactions. His advice was to stick with the kind of people

you know. He knew the west and its people. But he rarely used real people. 'The people in my books are typical of real people. They are people I have known, but they are my own invention. The problems are real-life ones, and I place the people in situations that exist.'

Still another series option is the crime-suspense type. Writer John D. MacDonald created Travis McGee, a 'salvage expert', – someone who finds stolen goods providing he gets to keep half. MacDonald did about twenty books in this series. He always felt that the more entertaining a book is the more readers it would reach. He chose crime-suspense as his field of writing because 'we are all murderers, we are all spies, we are all criminals, and to choose a crime as the mainspring of a book's action is only to find one of the simplest methods of focusing eyes on our life and our world'.

Author Richard Prather created a highly successful series about a detective named Shell Scott. It went on to sell millions of copies. Prather was a clerk at a military base when he sent in his manuscript. An editor thought it had value, and this led to his first action detective-mystery sale.

What made Prather's character interesting was that he was different; he mixed laughs with violence, which was unusual in the 1950s. If your character is like so many others, you may never see your series published. The trick is to make the character different in a number of ways. Then you have a real chance.

28 Flat Versus Well-rounded Characters

E.M. Forster outlined the key difference between flat (dull) and round (well-developed) characters in his very helpful work *Aspects of the Novel*. Flat characters are barely developed. 'They are constructed around a single quality or characteristic, and they give the illusion of being alive. They are never surprising. They please us by acting true to type, like the absurder schoolteachers of our youth.'

On the other hand, here is how he describes round characters: 'They have the incalculability of life. They are capable of surprises, have complex structures, and are fully developed.'

This distinction leads us to an important question. What is it that makes a character unforgettable? To answer the question we need only turn to some of the fiction classics. Remember the evil captain in *Mutiny on the Bounty*, and the clash between him and Fletcher Christian? Consider the lead character in *The Fountainhead*. Howard Roark, the architect, is a well-rounded character capable of surprises and quick decisions. His character has a complex structure. Think of Margaret Mitchell's Scarlett O'Hara, Rhett Butler, Ashley Wilkes and Melanie. They remain memorable characters.

Charlotte Brontë's *Jane Eyre*, Emily Brontë's *Wuthering Heights*, Hemingway's *For Whom the Bell Tolls*, Mary Shelley's *Frankenstein*, Theodore Dreiser's *Sister Carrie*, Henry Fielding's *Tom Jones*, Fitzgerald's *The Last Tycoon* and *The Great Gatsby*,

FLAT VERSUS WELL-ROUNDED CHARACTERS

all contain memorable and well-rounded characters.

But how does a writer go about creating a memorable, fully developed character ? You do it by giving the person traits that make him or her different. When Captain Queeg rolled little metal balls in his hand, in *The Caine Mutiny*, it clearly told us something about his condition. This is where you can be creative. By asking what traits you can give to a character, you juggle the possibilities. Some writers have an ability to borrow certain qualities and traits from real people, mix them around, and come up with an interesting character.

One clue in trying to create well-rounded characters is to make them human. Are they flawed in some way? Are they in touch or out of touch with reality? Are they practical or living in a dream world? Most fiction writers are observant. This ability to observe, to borrow a trait from one person, add a few from another, to mix qualities like a recipe, is invaluable in bringing fresh characters to life on the page.

Ask yourself constantly if your characters seem wooden. Do they go through their paces, their actions, as though they couldn't care less? If so, then you must rewrite them and instill the breath of life into them.

The simple technique of exaggerating your characters can make them more developed and realistic. Ask yourself the following questions:

- How can I make this character more interesting?
- How can I make him or her more inspiring?
- Is he or she too dull, too flat? Why?
- Do my characters have important objectives that drive them?
- Are the actions of this character consistent or do they wander all over the spectrum?
- How can I make the features and circumstances of their lives more dramatic?

Do not forget what I said about Charles Dickens: that he was more of a dramatist than a novelist. He dramatized the situations and events of his characters' lives. He presents every fiction

writer of today with a challenge. Can you, also, make stronger and better use of the power of dramatization? If you can, then your fiction, your characters, will leap from the printed page into the minds and hearts of your readers.

I strive to practise what I preach in my own writing. I work hard to dramatize the circumstances and situations of the characters I create. In creating my story about the court jester, I asked myself how I could dramatize this character's life more.

What I came up with was a crucial test that drastically changes his life and may, in fact, cost him his life.

I devised a plan to dramatize this test for the jester. I had the king invite some important guests to the castle for a banquet. The king expects the jester to entertain these guests and do it extremely well. Here is an excerpt from this test, which became a minefield for the poor jester.

> The balding aide scratched his eyebrow and admired his reflection in a mirror. The jester waited for him to speak.
>
> 'His majesty wanted to be sure you're ready for our guests. They arrive tomorrow.'
>
> 'I've been rehearsing for days,' said the jester. 'I'm ready.'
>
> 'Make no mistake about it, jester, these meetings are very important to the king. Our guests will grow weary of the long sessions and will need to be entertained at the banquet.'
>
> The following night the jester stood at the door of the great banquet-hall and waited to be announced. Ten minutes later, he was brought in before the guests, who were seated around a huge rectangular table.
>
> The king smiled at the jester and nodded.
>
> 'Entertain my guests, jester.'
>
> The jester bowed and began to perform. For the next forty minutes, the jester paraded before the assembly his best witty sayings, musical rhymes, jokes, and clown antics. Nobody laughed. No person present even appeared to be amused. It was a sad spectacle to behold and became increasingly embarrassing for the king.
>
> Something terrible had happened to the jester. He had lost

his gift, his magic ability to bring laughter to others. He tried one joke after another, humorous stories, rhymes that had always worked before and had brought roars of laughter. Nothing worked....

Desperate now and unsure what to try next, the jester went through a series of stumbles and falls on the floor. Surely that would amuse them, he thought. Not so. No laughs were heard. He stood on his head and recited a silly poem. That failed too. Not sure what to do next, he prattled off an old tongue twister, but it flopped as well. In fact, three guests gasped like they were in pain.

With tears now running down his cheeks, the poor jester could not bear it any longer. He turned toward the king, half-bowed, and then ran out of the banquet-hall.

This is an instance of dramatization. I placed my main character in a crucial test that soon leads to a great adventure for him at the risk of his life. This disaster for the jester comes in the first two pages, so the reader is hopefully drawn into it.

29 Make Your Characters Unforgettable

I still remember the shock I got one day as a child growing up in Indiana. My family was moving to Memphis, Tennessee, and my parents told me there was no way I could take my 5,000 or so comic books. I had to throw them all away, and it really hurt.

I look back on it now and marvel at the irony of life. I loved comic books, had hundreds of original *Superman*, *Batman*, *Captain Marvel* and other issues. Comic books experts today tell me I threw away about $15 million worth since many of them have increased enormously in value. I had thirty or forty *Submariner* comic books, originals included and one of these alone now is worth $113,000.

All the children in this small town had a wonderful time trading comic books. In this way we got to read all of them and collect the ones we wanted to keep. Those fictional characters made a strong impression on me and many of the other children.

The point of this anecdote is that fictional characters can seem so real, become so memorable, that some readers never forget them, regardless of the passing years. Several of my Indiana friends and I were so interested in those fictional comic characters that we wanted to be like them. They were our heroes. We may have been just seven or eight years old, but what did that matter?

One day four of us climbed to the top of the highest garage in town. We were wearing costumes we had made at home of our comic book heroes. Two of my friends were Captain Marvel and Batman. I was Superman. We wanted to be like our heroes and fly off the garage roof. We were crushed to discover we could not fly, that we were mere mortals, and would never be like our heroes.

The characters you create should touch the lives, hearts and spirits of your readers, perhaps influence them, inform, guide, instruct, entertain and possibly inspire them. Countless millions of readers everywhere seek to escape in the world of fiction. You make that possible. Readers want to enter the lives of your characters, see how they live, how they cope with and solve problems, how they interact with others, face life's tragedies and sadness, experience happiness, move ahead towards their dreams and objectives, make something out of themselves, and contribute something to their era and the world. Dickens, Stevenson, the Brontës, Hemingway, Poe, Fitzgerald, Mary Shelley and many others still entertain.

In the words of David Dortorf, writer, teacher, book enthusiast, and a former major television producer, 'Nothing is as lonely as the empty page. But the divine spirit moves us to fill it. Homer filled such a page three thousand years ago. We writers are custodians of a proud heritage. We are the bearers of the divine spirit. We must write and write ... whether it sells or not. Writers and authors keep the divine spirit alive. To dare to be creative is to keep the world in something of a state of grace.' Aristotle put it this way: 'The ennobling of the human spirit comes to us via the written word.'

Never forget that as a fiction writer you are God. You provide the spark of life that brings characters to centre stage, to life on the page, and characters should entertain and enrich the lives of readers. The world you create on paper is the arena for your characters. Listen well when they whisper in your ear and tell you what they want to do.

May you find the fictional dreams that are uniquely yours, your own original voice, and entertain and influence readers

with unforgettable characters. I shall see you out there in the wonderful world of fiction. More power to you and your characters.